STUDIO SECRETS

STUDIO SECRETS

MOSAICS

Verdiano Marzi
Fabienne Gambrelle

Photographs
Florent de La Tullaye

SEARCH PRESS

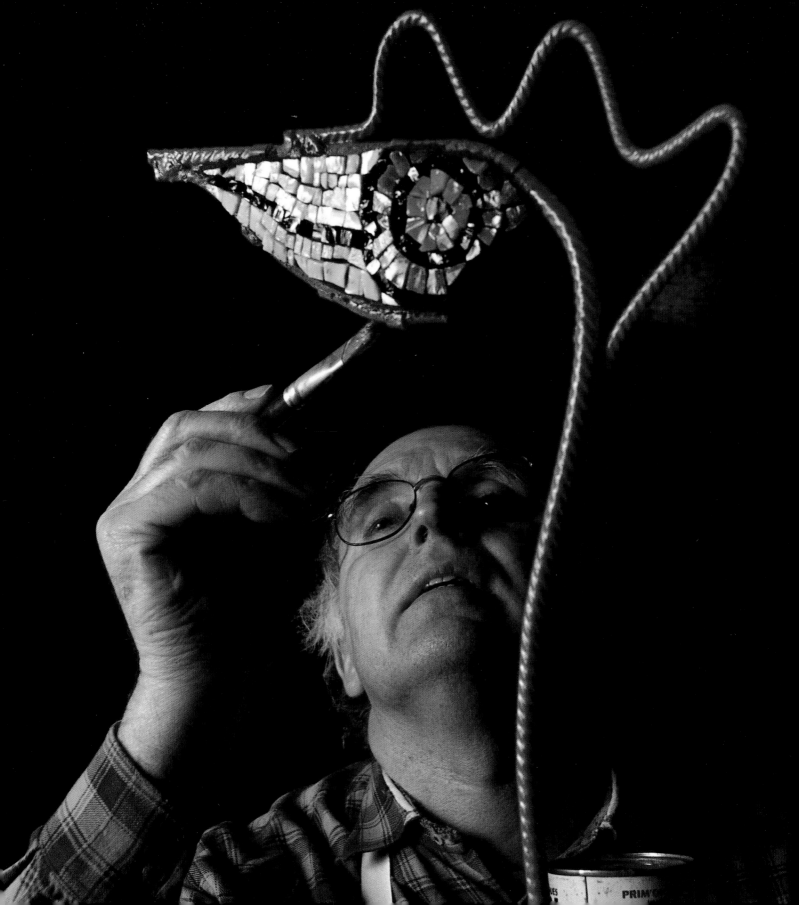

FOREWORD

With a name partly inspired by the composer Giuseppe Verdi, Verdiano Marzi might well have become a musician, but his love of design determined otherwise. The son of farmers from Ravenna, an important centre of Byzantine mosaic, Verdiano Marzi was admitted to the town's school of art at the age of just eleven. He became a master mosaicist in 1968, and joined the studio of Carlo Signorini, the son of Renato Signorini, a key figure among Italian mosaicists, who revolutionised the teaching of mosaic art. Signorini worked with the great artists of his time, such as Marc Chagall and Gino Severini. Severini was an Italian artist who first aligned himself with the Futurist movement and then moved through cubism to a neoclassical style. His ideas helped give birth to mosaic art as we know it today. Marzi's contact with Renato Signorini had an impact on his apprenticeship at the family studio in Ravenna, as he rubbed shoulders with this 'maestro of mosaic' on a daily basis for several years.

Verdiano Marzi left Italy in 1973 and moved to Paris, where he entered the fine arts scene. He was now twenty-three years of age and embarking on his chosen profession, with a burgeoning desire to reveal and communicate the beauty of mosaic and the secrets buried within glass and stone. These concealed treasures, which only come to light when these materials are broken up by the mosaicist, never fail to leave Marzi dazzled and dumbstruck, and he hopes to share this continuous feeling of wonderment with you through this book. By offering up his knowledge, Verdiano Marzi hopes to give you a greater understanding of mosaics and inspire you to create such works of art yourself.

08

16

38

86

PROCEDURE

BASIC TECHNIQUES

PROJECTS

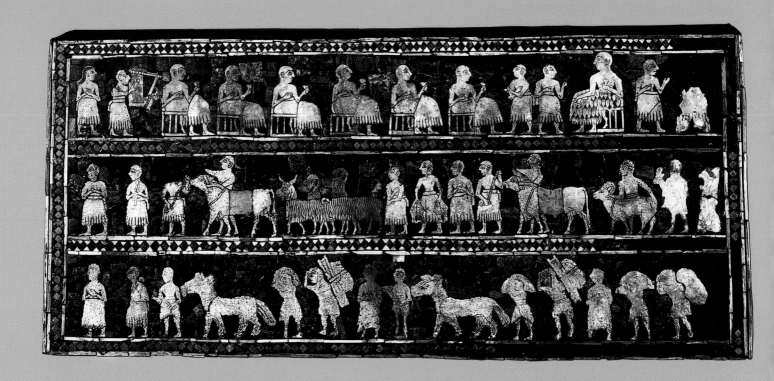

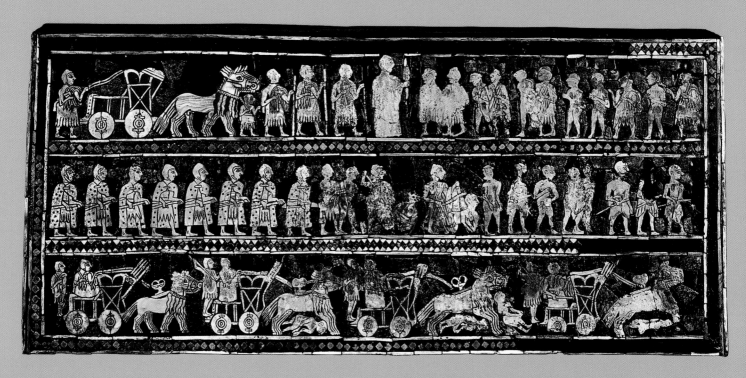

ROYAL STANDARD OF UR (2750 BC) – TOP: 'PEACE' PANEL; BOTTOM: 'WAR' PANEL – BRITISH MUSEUM, LONDON.

HISTORY OF THE PROFESSION

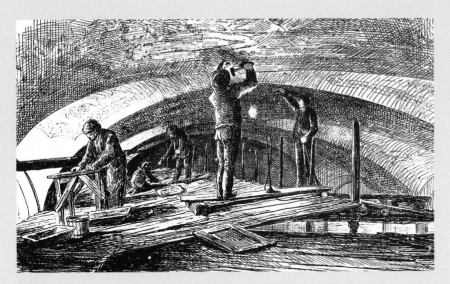

WORKS AT OPÉRA GARNIER: MOSAICISTS DECORATING THE ROOF OF THE ENTRANCE FOYER; ENGRAVING BASED ON A DESIGN BY M. L. HOUSSOT.

Although the mosaic artists of today generally put their name to their work, in the past the majority remained unsigned – especially in the case of models or sketches by famous painters such as Cimabue Giotto or Paolo Uccello. This was because their standing as artisans had long since dwindled to the lowly status of copyists recreating works designed by other artists. Seen for centuries as merely 'painting in stone', mosaic fortunately made a comeback at the end of the nineteenth century. Since then it has shown that it is an art in its own right, giving rise to some singular pieces thanks to its own peculiar attributes: fragmentation and the play of light resulting from the brilliance of its materials.

Shells, mother-of-pearl and lapis lazuli have been skilfully combined in the 'Standard of Ur', one of the oldest mosaics in the world. The columns of Uruk, faced at their base with terracotta cones showing geometric motifs, were excavated in Mesopotamia, and these decorative compositions (dating from 3000 to 1500 BC) preceded those of the Greeks, who were the first to create mosaic floors. These were made of whole pebbles (which later on were cut down in size), as well as pieces of lead and marble tiles.

The use of regular-shaped fragments, known as tesserae, started in Alexandria in the third century BC. It was the Romans who perfected the art of paving and provided us with the first known mosaicist, Sosus – the artist who created a floor at Pergamon. Written texts as well as a bas-relief found in Ostia (Italy) give us an idea as to how the work was organised between a team of mosaicists in Roman times: the image was drawn in colour by the *pictor imaginarius*, who was the best-paid member of the group. The *pictor parietarius* then copied the cartoon on to the surface to be decorated, while the *pavimentarius* was responsible for preparing the ground and the *calcis coctor* the mortars. The background and the simple frieze patterns were made by the *tessellarius*. The more intricate and complex areas were the work of the *musivarius* or master mosaicist. He was paid just a third of what the *pictor imaginarius* received and earned no more than a baker in Roman times.

In Byzantium, mosaic art portrayed themes from Christianity and succeeded in throwing off certain constraints that are imposed when mosaic is used for paving. Unlike mosaic floors, mosaic work decorating walls or ceilings no longer needed to be completely regular, so it offered new opportunities for exploring light and its reflection. Byzantine basilicas and portable mosaic icons were dominated by gold and silver, while designs from Roman times favoured black, red and white. This tradition was

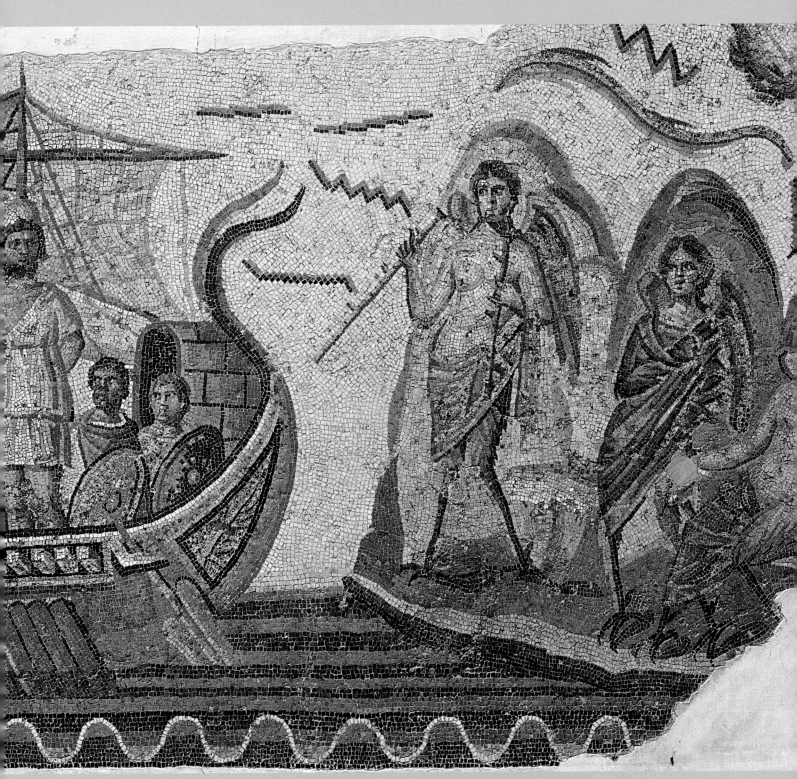

ROMAN MOSAIC FROM THE THIRD CENTURY SHOWING ULYSSES AND THE SIRENS, DOUGGA (TUNISIA).

broken by St Mark's Basilica in Venice, which not only borrowed motifs from painting but also made use of its artists: Paolo Uccello, Michele Giambono, Titian, Veronese and Tintoretto all worked here. Their designs were executed in mosaic work that looked as if it had 'been painted in oils' (Vasari), like those created by the Vatican School of Mosaic when decorating St Peter's Basilica in Rome.

With construction of the Paris Opéra in the nineteenth century, mosaic enjoyed a revival as an art in its own right. The architect Charles Garnier dreamed of covering the monuments of the French capital with 'marble and enamel'. 'The entire city [would become] a harmonious reflection of silk and gold.' The mosaic artist Giandomenico Facchina, an Italian immigrant from Friuli who had moved to France, helped him to realise his lustrous vision. The innovative techniques devised or redeveloped by Facchina resulted in a major reduction in the cost and time for mosaic work. This allowed the Opera House to be adorned with numerous decorations which were first made in the studio, using the reverse technique, and then put in place.

Possibly already in existence in the Middle Ages but never practised before, this indirect technique, which was patented by Facchina in 1858, greatly facilitated the organisation and execution of work on site. This helped mosaic art to become more widespread, and it really came into its own all over the world from the end of the nineteenth century. By creating mosaics,

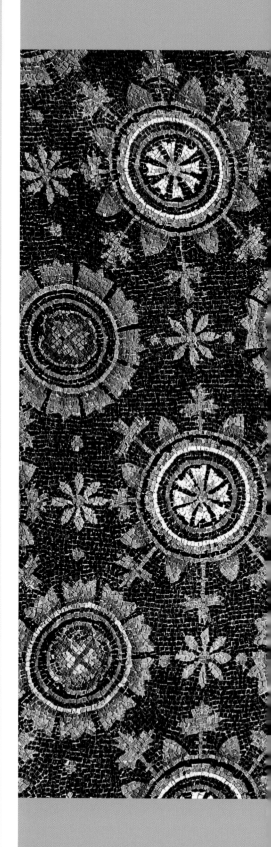

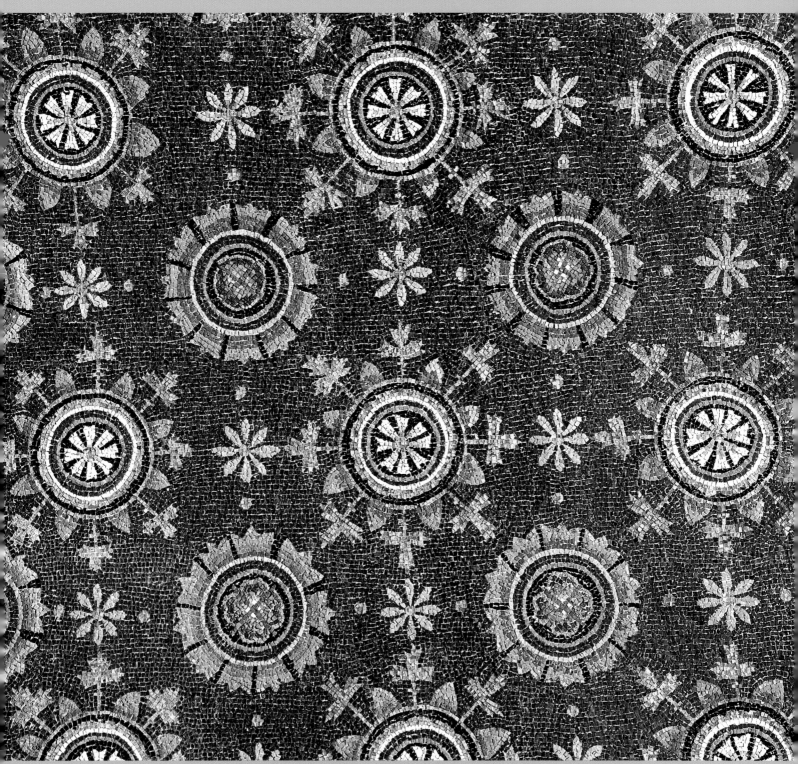

STARRY NIGHT ON A BARREL VAULT IN THE MAUSOLEUM OF THE GALLA PLACIDIA, RAVENNA (ITALY).

Gustav Klimt, Antonio Gaudí, Robert Delaunay or even Diego de Rivera paved the way for the artistic recognition of the genre. Mosaic thus blossomed from the 1930s, cutting the 'umbilical cord still linking it to painting', in the words of the mosaic artist Giovanna Galli, a member of the Anaxagoras Group along with Verdiano Marzi.

Founded with Riccardo Licata, who was their tutor at the École des Beaux-Arts de Paris and assistant to Gino Severini, this group of artists adopted the name of a philosopher from Ancient Greece, who postulated the idea of the mind as the supreme ordering principle. Giovanna Galli, Verdiano Marzi and Riccardo Licata took up this concept – breaking up materials to reorganise them by alternating tiles and spaces, tesserae and interstices, and arranging them to produce an irregular and fragmented whole that creates the vibrant and luminous effect special to mosaics.

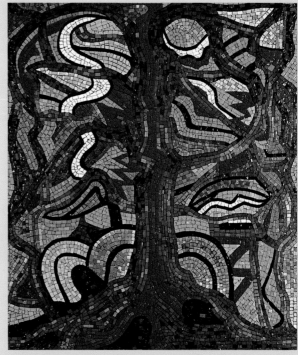

TREE, COMPOSITION IN RED, BLACK, BLUE AND YELLOW BY JACOBA VAN HEEMSKERCK (1876-1923), HAAGS GEMEENTEMUSEUM, THE HAGUE (THE NETHERLANDS).

OPPOSITE: *L'ATLANTIDE* BY VERDIANO MARZI.

After the Anaxagoras Group was founded, other artists followed suit, so contributing their own ideas to the lively mosaic scene of today, where the *pictor imaginarius* and the *musivarius* have now become one and the same person. In France the work of mosaic artists is promoted by three associations based at Chartres, Paray-le-Monial and Aubernay. In Italy the professional designation of mosaicists depends on whether they have trained at the schools of mosaic art at Ravenna or Spilimbergo or in the fine arts. Elsewhere in Europe, but also in Australia, the United States, Japan and Chile, the work of mosaic artists has meanwhile completely transformed the image of mosaic created over the centuries.

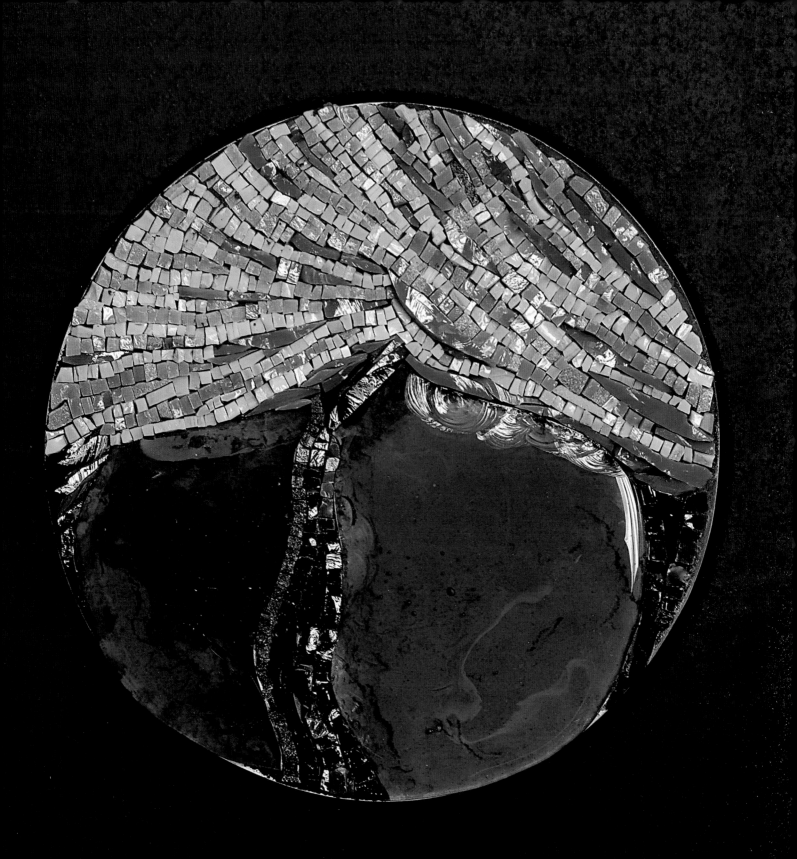

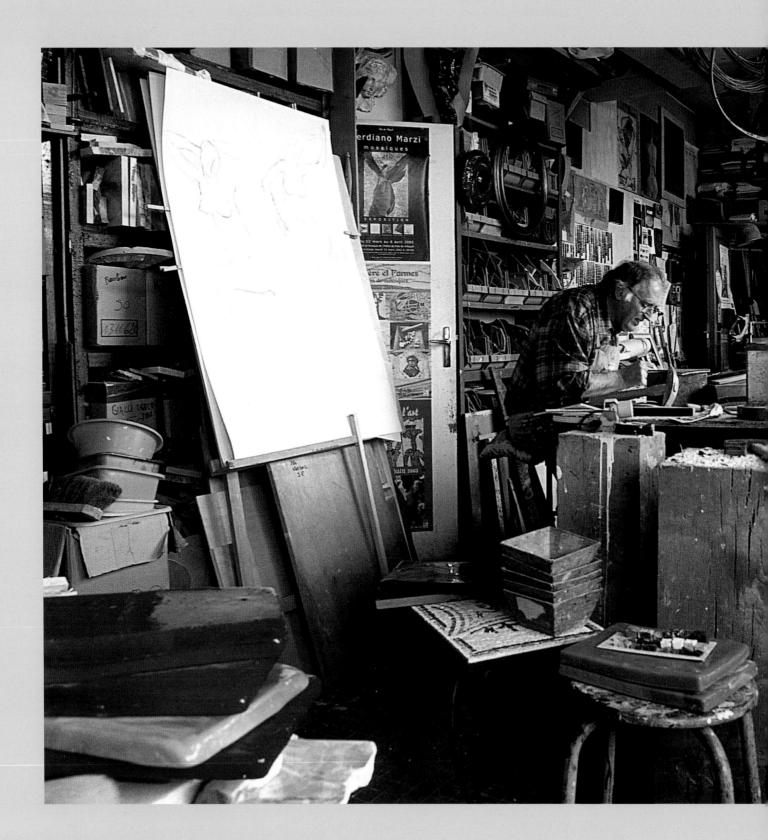

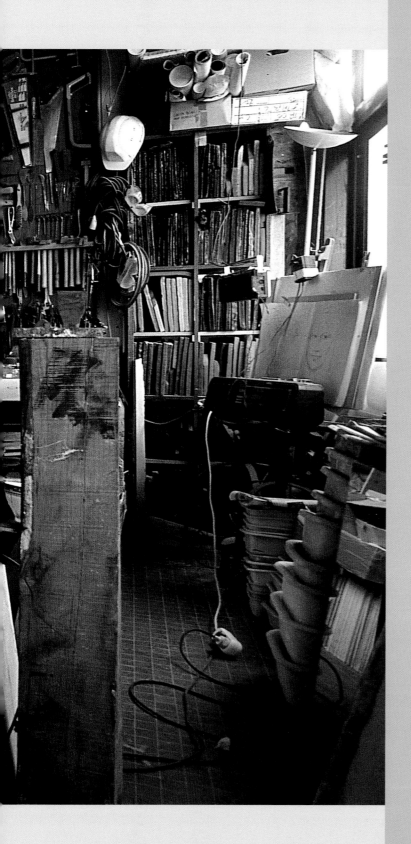

A VISIT TO THE WORKSHOP

VERDIANO MARZI'S STUDIO CAN BE FOUND ON THE GROUND FLOOR OF A COUNCIL BLOCK, ON THE HEIGHTS OF BAGNOLET IN THE DEPARTMENT OF SEINE-SAINT-DENIS. A ROYAL BLUE FRONT DOOR OPENS TO REVEAL A LONG ROOM BURSTING WITH OBJECTS AND ILLUMINATED BY MOSAIC LUNETTES AND HUGE WINDOWS OF FROSTED GLASS. ENTHRONED IN THE MIDDLE THERE IS A LARGE PLANK OF BATTERED WOOD, SCRATCHED AND FLECKED WITH PAINT AND PROPPED UP ON STACKS OF MARBLE AND BOXES, THAT SERVES AS A WORKBENCH.

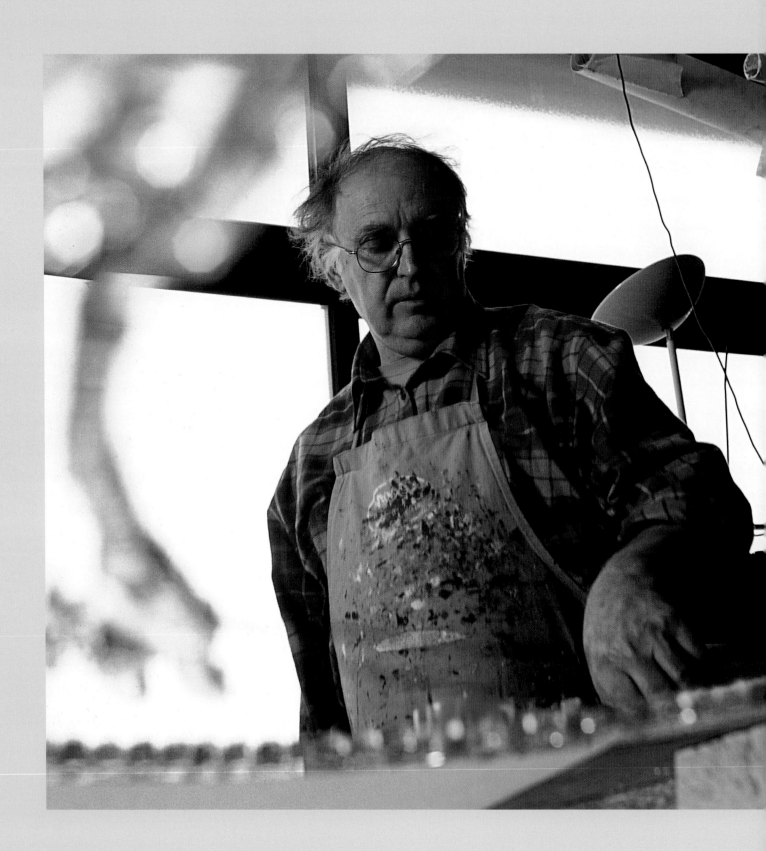

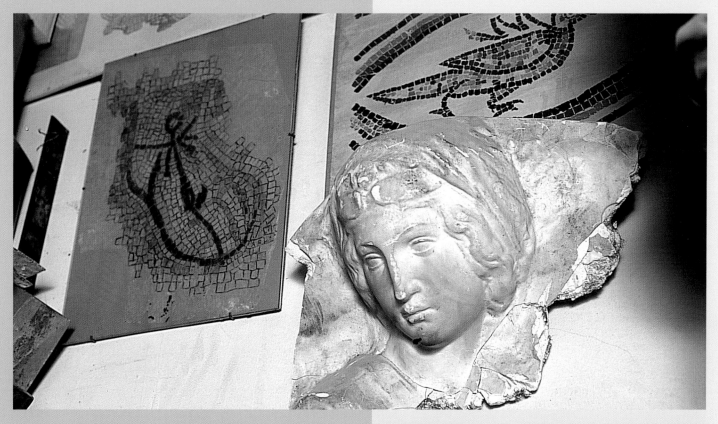

THE WORKSHOP

HERE WE CAN SEE THE WORK OF VERDIANO MARZI, HANGING ON THE WALLS, MOUNTED ON PEDESTALS OR DISPLAYED ON STANDS. LUNETTES IN WHITE OR PURPLE, WINTERY SHADES OF BLUE, BERBER-INFLUENCED 'BLACK SPRING' WORKS AND GOLDEN STATUES ILLUMINATE THE ROOM, WHICH IS COVERED BY A FINE LAYER OF DUST FROM THE MORTAR AND GROUT. PIERCING THIS FILM IS THE GLEAM OF GLASS TILES, WHICH HAVE BEEN BROKEN UP AND PUT AWAY IN A SORT OF CABINET, CROWNED WITH PANELS OF SHIMMERING MOSAIC.

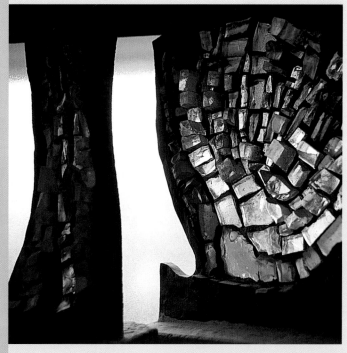

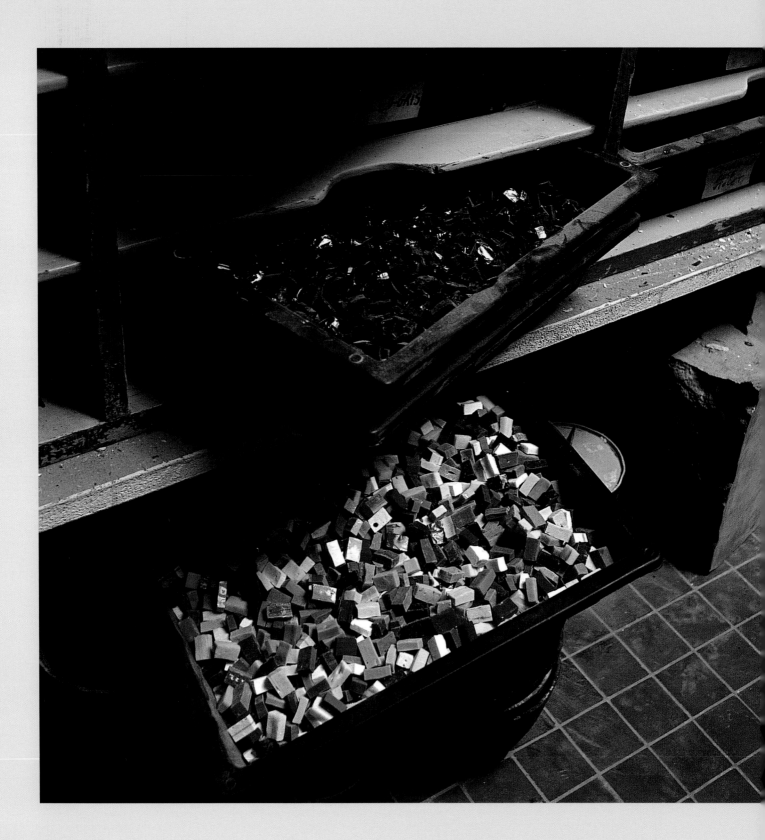

THIS STUDIO IS HOME TO SEVERAL TONNES OF MATERIAL. THE TILES ARE KEPT IN TRAYS, EACH LABELLED ACCORDING TO COLOUR AND ORIGIN. MARBLE – INCLUDING PORTUGAL PINK, GUATEMALA GREEN, AND VERONA PINK, JUST TO MENTION A FEW – IS STORED IN BUILDERS' TROUGHS OR PASTA TRAYS GIVEN TO VERDIANO MARZI BY A FORMER STUDENT WITH A RESTAURANT. THE GLINT OF SHARP-EDGED GLASS TILES AND THE ELEGANT VEINING OF MARBLE SLABS RESEMBLE GEMS THAT HAVE SOMEHOW BECOME MISLAID.

VERDIANO MARZI WENDS HIS WAY BETWEEN WALLS LINED WITH SHELVES, COVERED WITH TOOLS, SCULPTURES, PLASTER CASTS, POSTERS, DRAWINGS, MARBLE SAMPLE CARDS AND GLASS TILES. PREPARATION OF THE BASE, WHICH IS OFTEN A NOISY AFFAIR INVOLVING SAWS OR DRILLS, IS FOLLOWED BY CUTTING OF THE TILES, TO THE ACCOMPANIMENT OF MUSIC WITH A CLEAN, SHARP, REPETITIVE RHYTHM. THE STUDIO IS THEN PLUNGED INTO SILENCE WHEN MARZI STARTS ACTUALLY MAKING THE MOSAIC. THE ONLY SOUNDS ARE THE CHINK OF THE TILES AS THEY ARE REMOVED FROM A TRAY OR REPLACED, AND THE SCRAPE OF THE PALETTE KNIFE PICKING UP A DAB OF MORTAR IN THE BOWL AS EACH FRAGMENT IS PLACED SLOWLY AND METHODICALLY IN THE MOSAIC. IT IS A PLEASANT, PEACEFUL TASK THAT IS ENTIRELY IN KEEPING WITH MARZI'S OWN NATURE.

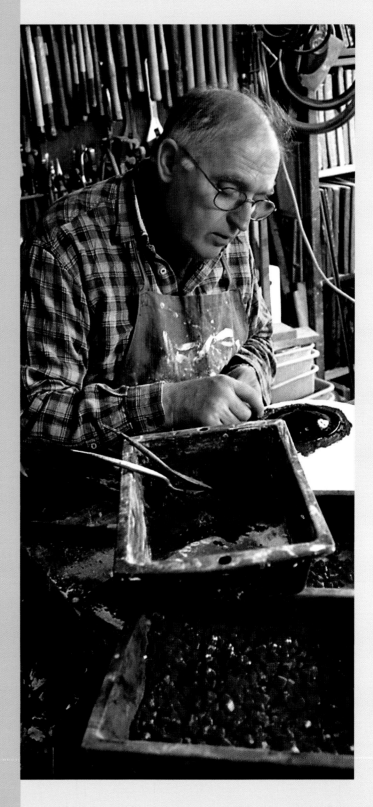

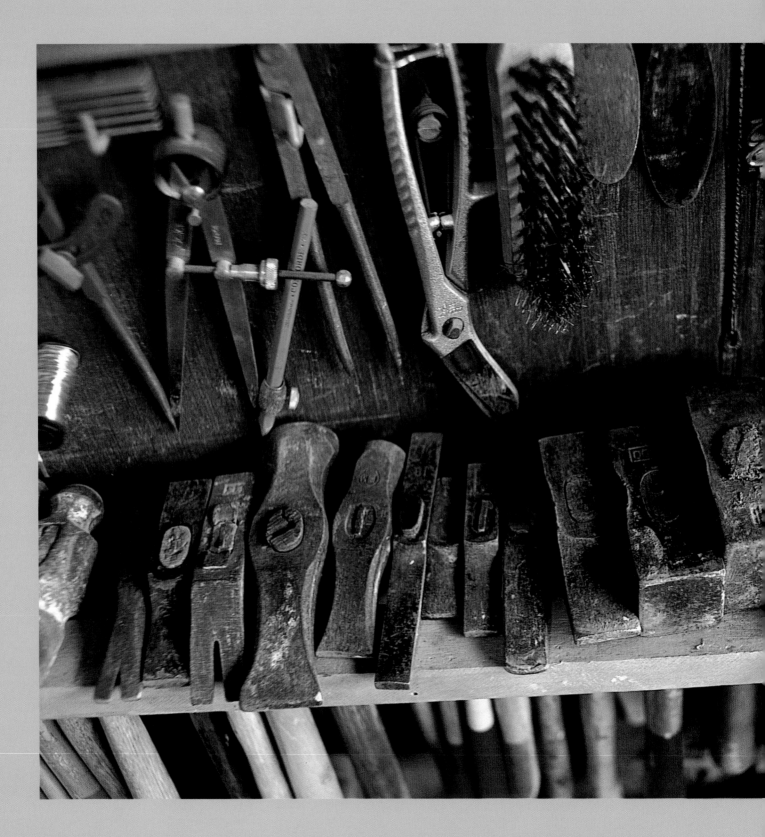

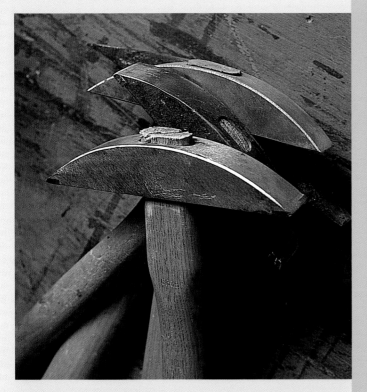

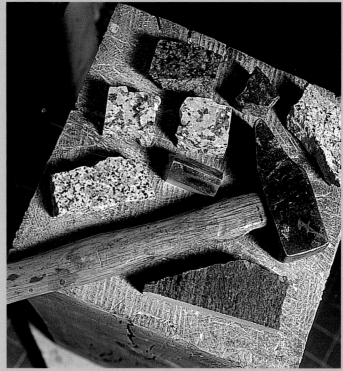

GRANITE IS CUT USING AN ORDINARY HAMMER.

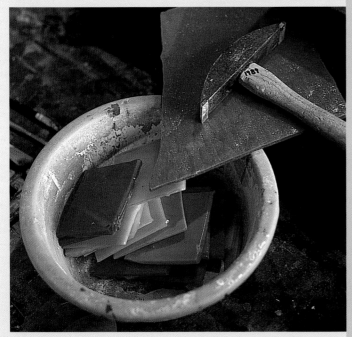

THE MOSAIC HAMMER, WITH A HEAD MADE OF HARDENED STEEL AND
TUNGSTEN-TIPPED AT EACH END, IS USED TO CUT THE GLASS; MARBLE, ON
THE OTHER HAND, DOES NOT REQUIRE A TUNGSTEN-TIPPED HAMMER.

TOOLS

THE VARIETY OF TOOLS FOUND IN THE STUDIO BEARS
WITNESS TO THE MANY DIFFERENT TASKS INVOLVED IN
MAKING A MOSAIC. THE INDIVIDUAL STEPS OF TILE
CUTTING AND LAYING CALL FOR SPECIAL TOOLS, WHICH
HAVE BEEN COLLECTED BY VERDIANO MARZI, WHO EVEN
WRITES THE DATE THEY WERE ACQUIRED ON THE HANDLE.
PREPARATION OF THE BASE MAY ALSO NEED A WHOLE
RANGE OF TOOLS, DEPENDING ON THE MATERIALS BEING
USED IN THE MOSAIC.

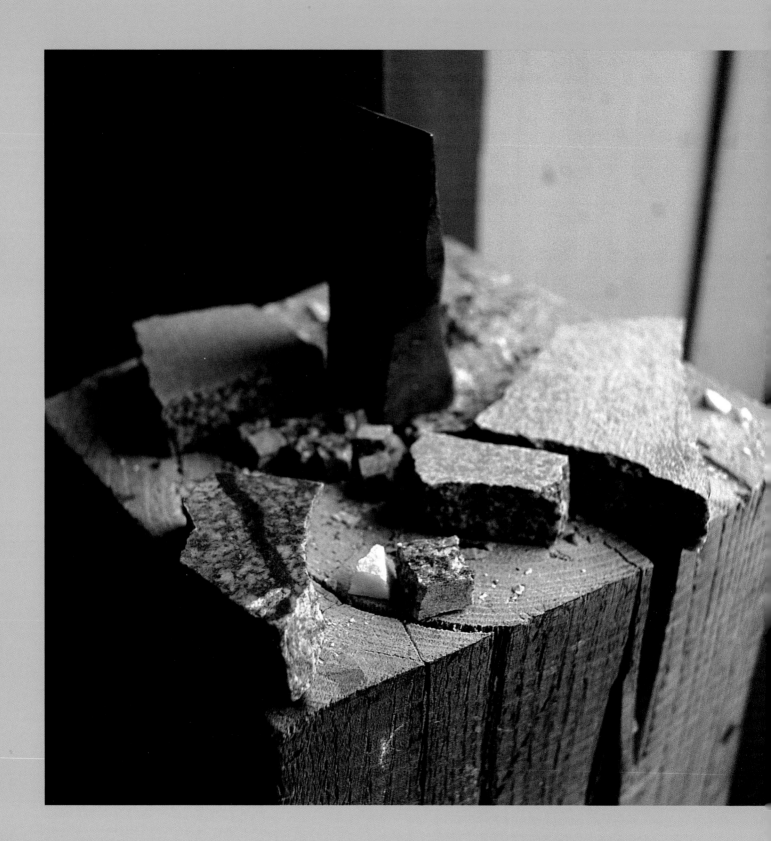

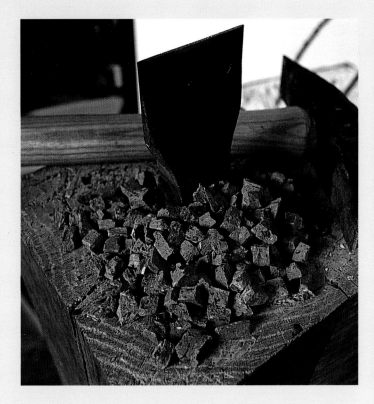

THE MATERIALS ARE CUT TO SIZE USING A HARDIE OF
WROUGHT IRON WHICH IS GENERALLY MOUNTED IN A
BLOCK OF WOOD. HOWEVER, PORTABLE VERSIONS ARE
ALSO AVAILABLE.

ABOVE, FROM LEFT TO RIGHT:
AN ORDINARY HARDIE MADE OF HARDENED STEEL IS SUFFICIENT TO CUT
GRANITE, BRICK AND MARBLE; GLASS REQUIRES A TUNGSTEN-TIPPED BLADE.

RIGHT:
WHEN CUTTING GLASS TO SIZE, THE ARTIST FIRST USES A HAMMER FOLLOWED BY
GLASS CUTTERS. GLASS CUTTERS MADE OF BRASS, WHICH ARE OLDER THAN THE
MODEL SHOWN HERE WITH A PLASTIC HANDLE, HAVE A DIAMOND-TIPPED WHEEL
AT ONE END. AT THE OTHER END THE HANDLE BULGES OUT SO IT CAN BE USED TO
STRIKE AND BREAK THE SHEET OF GLASS ONCE THE INCISION HAS BEEN MADE.

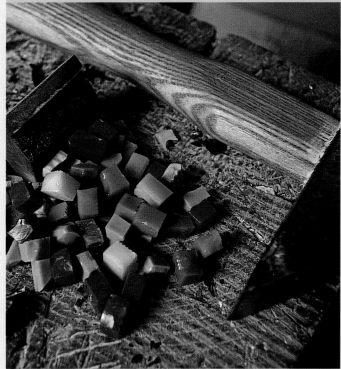

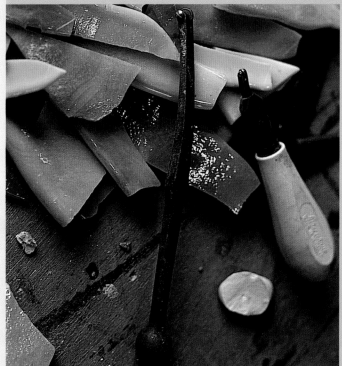

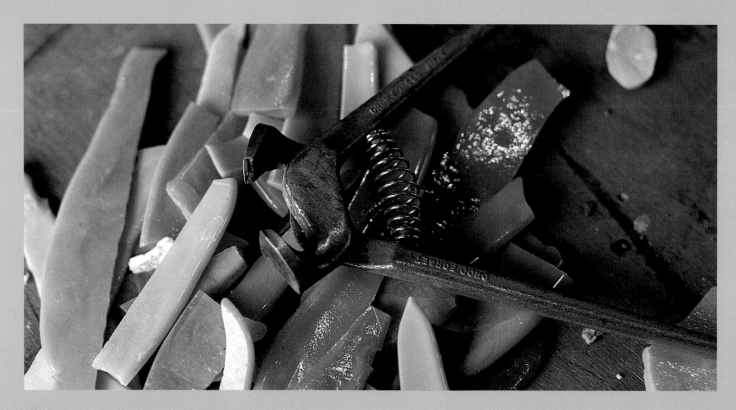

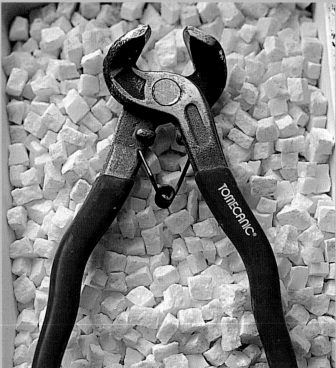

LEFT AND ABOVE:
TILE NIPPERS CAN BE USED TO CUT UP GLASS AND CERAMIC TILES OR RESIZE
THEM AS NEEDED DURING THE LAYING PROCESS.

OPPOSITE PAGE:
LEFT-HAND PICTURE: TO THE LEFT, SPATULAS USED TO APPLY THE MORTAR IN
WHICH THE TESSERAE ARE SET IN A MOSAIC. TO THE RIGHT, PLIERS USED TO
REMOVE OR REPOSITION THEM WHEN THE MORTAR IS STILL FRESH.

RIGHT-HAND PICTURE: TROWELS USED TO MIX AND APPLY MORTAR. THE FINEST
ARE NICKNAMED 'CAT'S TONGUES'.

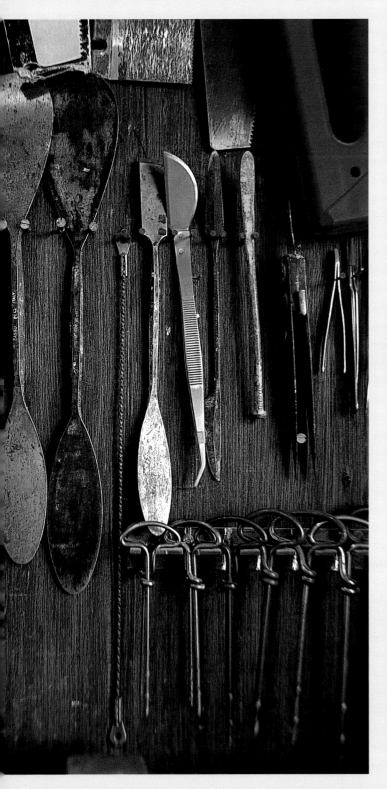
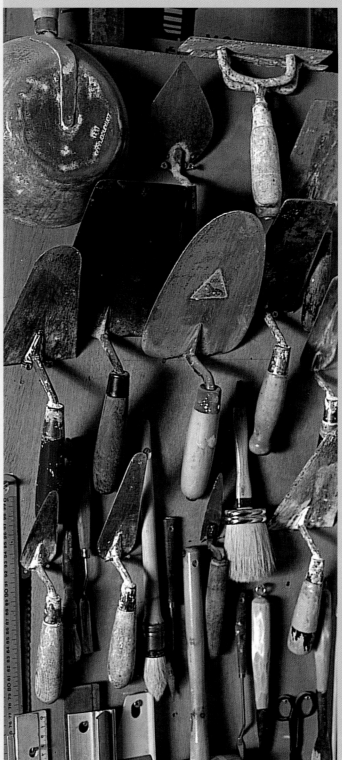

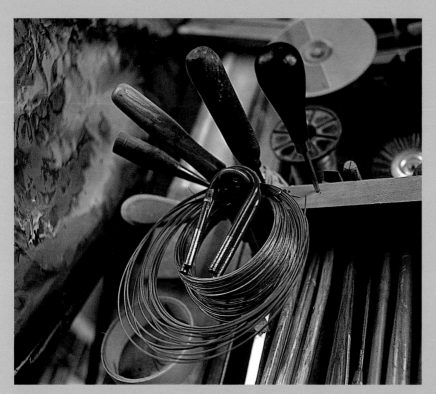

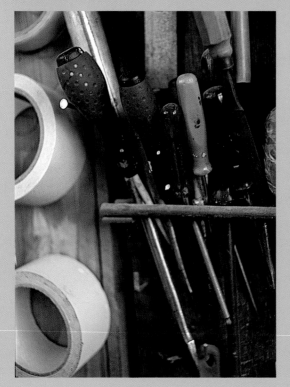
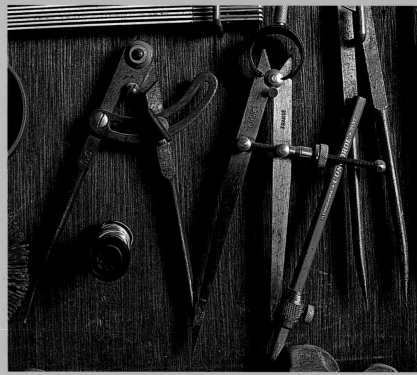

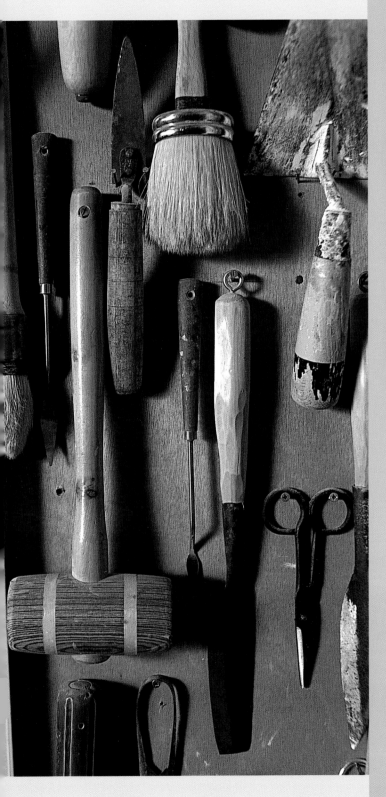

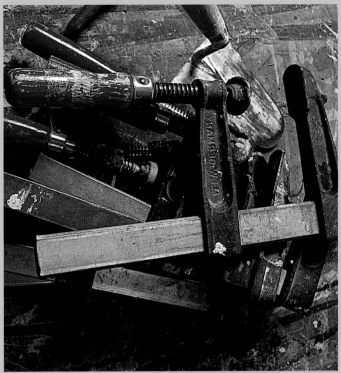

WHEN MAKING UP BASES FOR MOSAIC WORK, MOSAICISTS HAVE TO BE ABLE TO DEAL WITH WOOD, METAL AND POLYSTYRENE. THEY THEREFORE HAVE AN EXTREMELY WIDE RANGE OF TOOLS, WHICH ALLOW THEM TO TURN ALL SORTS OF MATERIALS INTO A PEDESTAL OR FRAMEWORK – FOR EXAMPLE SAWS, BRADAWLS, COMPASSES, PINCERS, PLIERS AND SCREWDRIVERS.

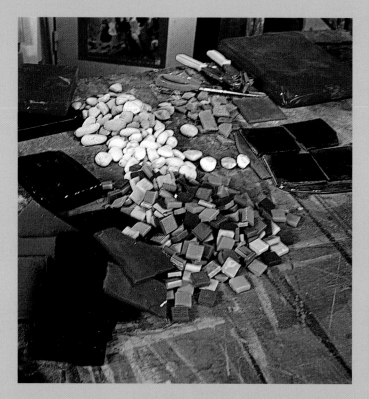

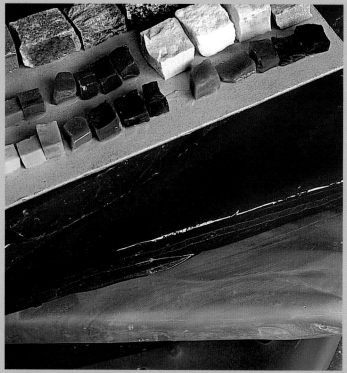

MATERIALS

THE FIRST STEP TOWARDS MAKING A MOSAIC IS TO APPRECIATE THE MAGIC OF THE MATERIALS, WHETHER USING MAN-MADE MATERIALS, SUCH AS GLASS, CERAMIC TILES, SANDSTONE AND BRICK, OR ITEMS COLLECTED FROM NATURE, SUCH AS PEBBLES, SHELLS, SMALL STONES, SLATE, GRANITE AND MARBLE.

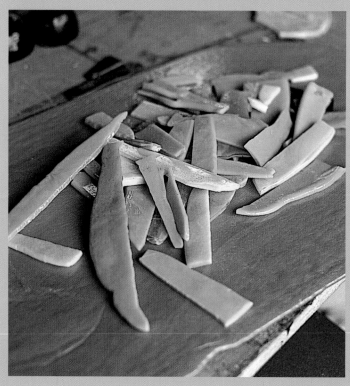

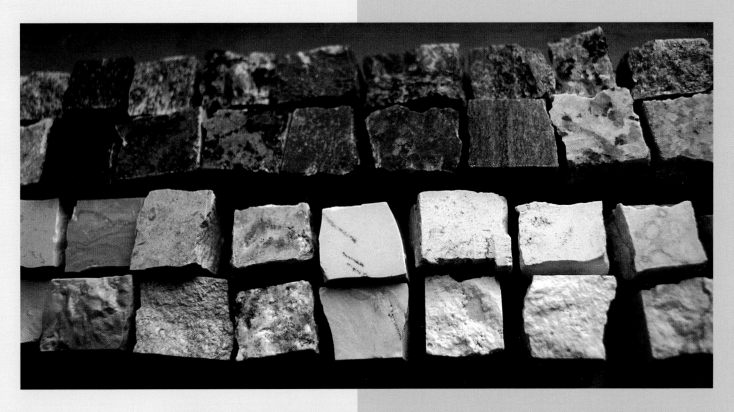

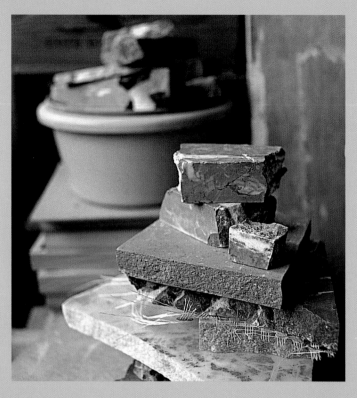

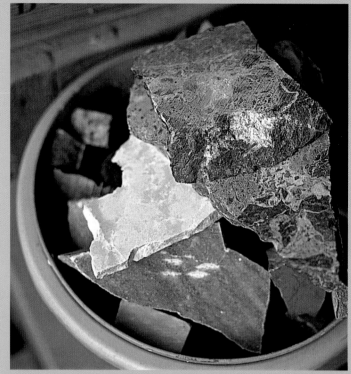

• MARBLE

MARBLE IS A HARD ROCK WITH A FINE CRYSTALLINE STRUCTURE THAT IS CATEGORISED AS ONE OF THE MOST DENSE AND RESISTANT OF LIMESTONE MATERIALS. MARBLE MAY BE PLAIN IN COLOUR, VARYING BETWEEN BEIGE, WHITE, BLUE, GREY-GREEN OR VIOLET, OR PATTERNED WITH ELEGANT VEINS ON A BLACK OR PINK BACKGROUND. VERDIANO MARZI'S FAVOURITE MARBLE COMES FROM SOUTH AMERICA. WITH ITS SKY-BLUE COLOUR AND WAVY PATTERN, MACAUBA MARBLE FROM THE ANDES RELATES EQUALLY TO THE ELEMENT OF AIR AS TO THAT OF WATER.

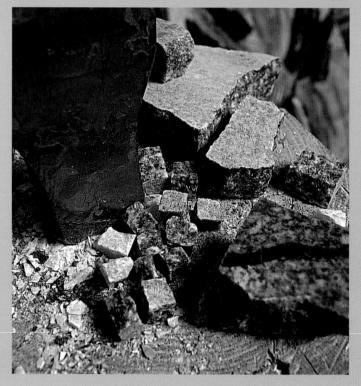

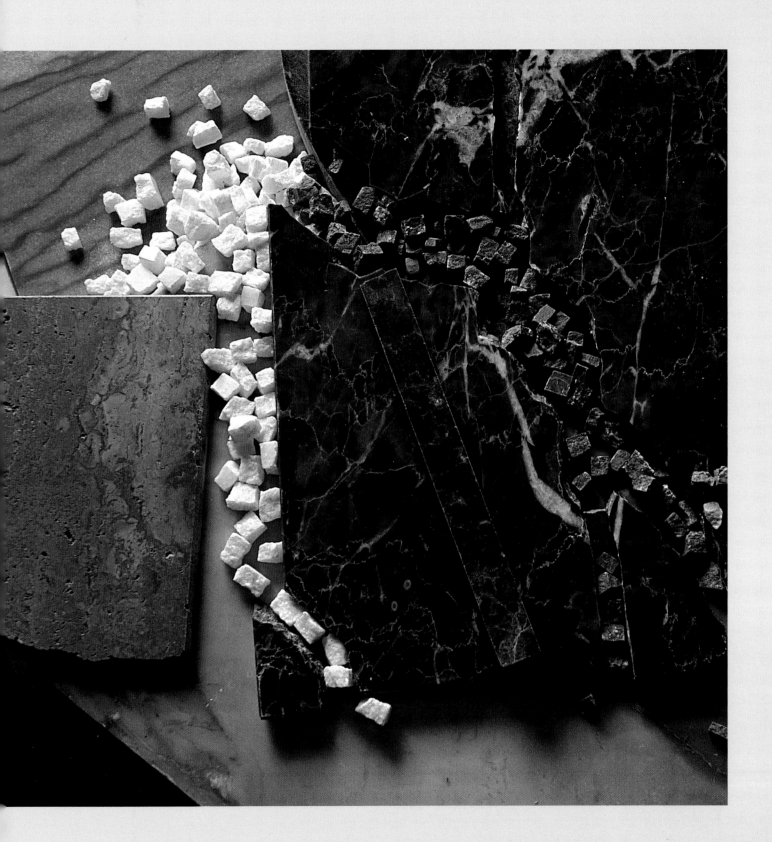

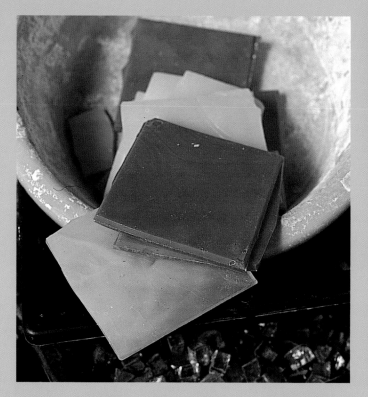

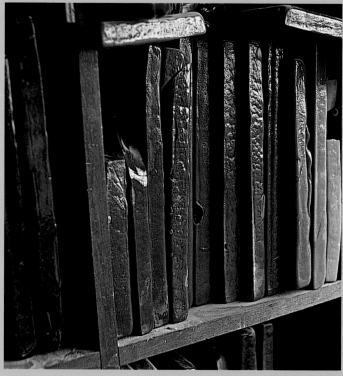

• VITREOUS GLASS

GLASS FIRST APPEARED IN MOSAICS IN THE FIRST CENTURY AD, HAVING UNTIL THEN ONLY BEEN USED BY JEWELLERS AND BY GOLD- AND SILVERSMITHS.

FROM LEFT TO RIGHT:
VITREOUS GLASS IN THE FORM OF TILES, WEIGHING FROM 100G (3½OZ) TO SLABS OF 3KG (6LB 10OZ). IT IS MADE BY MELTING SAND, CALCIUM OXIDE, SODIUM OXIDE OR POTASSIUM OXIDE TOGETHER WITH COLOURING AGENTS AT TEMPERATURES VARYING BETWEEN 1300°C AND 1500°C.

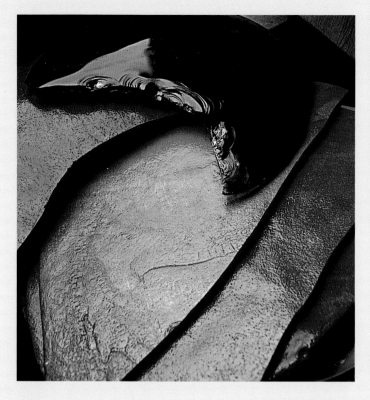

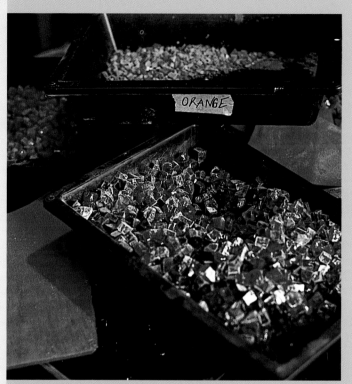

ABOVE:
SMALTI, A BLEND OF COLOURED GLASS AND LEAD, IS MANUFACTURED IN THE FORM OF SO-CALLED 'PIZZAS' OR PANCAKES WITH DIAMETERS VARYING BETWEEN 15 AND 30CM (6 AND 11¾IN), AND IT IS THE LEAD IN THE MIXTURE THAT GIVES THE MATERIAL ITS SPECIAL SHEEN. VITREOUS GLASS AND SMALTI SPARKLE WHEN THEY ARE CUT UP INTO TESSERAE.
VITREOUS GLASS AND SMALTI, PRODUCED BY GLASSWORKS, ARE SOMETIMES CALLED 'ENAMELS', AND ARE REFERRED TO AS THIS BY ENAMELLERS AND SILVER/GOLDSMITHS.

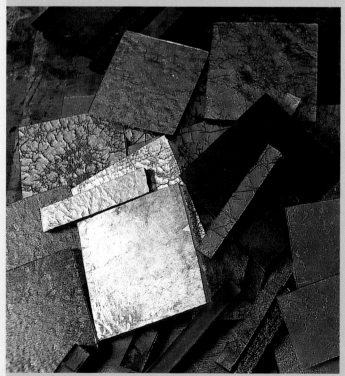

RIGHT:
GOLD GLASS TILES ARE MANUFACTURED USING TWO TECHNIQUES: GOLD LEAF IS SANDWICHED BETWEEN A LAYER OF CRYSTAL AND GLASS, OR THE CRYSTAL IS TINTED. THE FIRST PROCEDURE IS THE TRADITIONAL METHOD BUT IS MORE COSTLY. IT LOOKS QUITE SPLENDID, HOWEVER, RESULTING IN A LUSTRE THAT IS CHARACTERISTIC OF BYZANTINE ART.

As vitreous glass is not cheap, you can use ceramic tiles instead. A mixture of glass and clay, they are more affordable. Such tiles are made using a lattice framework so they are already in the shape of little squares once they have been fired.

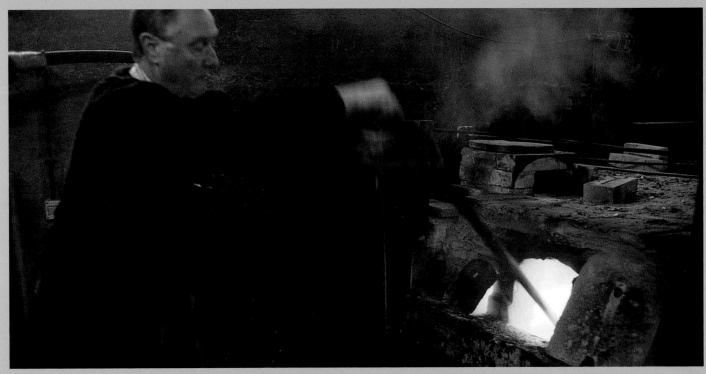

GÉRARD ALBERTINI FIRES A 300KG BATCH OF GLASS EVERY DAY, NINE MONTHS OF THE YEAR. THE FIRING PROCESS TAKES NINETEEN HOURS.

VERDIANO MARZI BUYS IN THE SMALTI AND GLASS TILES HE NEEDS FROM TRADITIONAL GLASSWORKS: ANGELO ORSONI IN VENICE AND GÉRARD ALBERTINI AT MONTIGNY-LÈS-CORMEILLES, IN THE PARIS SUBURBS. THE ALBERTINI FACTORY IS A FAMILY FIRM THAT IS NOW IN ITS THIRD GENERATION. GÉRARD ALBERTINI'S GRANDFATHER WAS A MASTER GLASSMAKER IN MURANO. HIS SON EMIGRATED TO FRANCE IN 1925 AND, USING THE RECIPES HANDED DOWN BY HIS FATHER, HE WAS RESPONSIBLE FOR PRODUCING THE GLASS TILES USED TO DECORATE THE BASILICA IN LISIEUX. HIS OWN SON, GÉRARD ALBERTINI, NOW WORKS ALONGSIDE HIS WIFE AND DAUGHTER AND IS ONE OF THE LAST TRADITIONAL GLASSMAKERS IN EUROPE, ALONG WITH ORSONI OF VENICE, MARIO DONA IN SPILIMBERGO AND STEFANO DONA AT MURANO, ITALY.

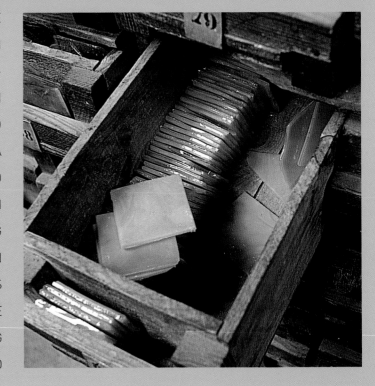

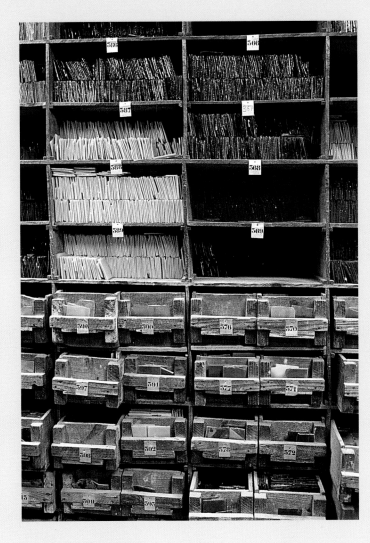

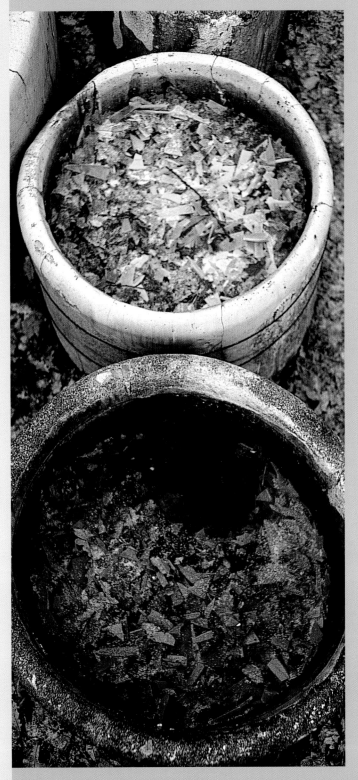

LEFT-HAND PAGE AND ABOVE:
THE SHEETS OF GLASS ARE FLATTENED IN A PRESS, THEN FIRED IN A FURNACE
FOR FIVE DAYS AT DECREASING HEAT BEFORE FINALLY BEING CUT INTO SQUARES
OR RECTANGLES. THE PHOTOGRAPH ABOVE SHOWS HOW THE GLASS SHEETS ARE
LINED UP ON SHELVES IN AN ENORMOUS 'BOOKCASE' FASHIONED BY GÉRARD
ALBERTINI'S FATHER OUT OF OLD WINE BOXES. CUSTOMERS BUY THEIR
MATERIALS BY WEIGHT, WITH THE PRICE DEPENDING ON THE COLOURS, AS SOME
COLOURANTS ARE VERY EXPENSIVE. GÉRARD ALBERTINI CAN ALSO OFFER
CUSTOMISED SHADES FOR ARTISTS.

RIGHT:
SOMETIMES A MELTING POT BREAKS IN THE HEAT. IT IS THEN THROWN OUT IN THE
GARDEN AND FILLED WITH WASTE GLASS. VISITORS CAN HELP THEMSELVES
FROM SUCH POTS AND BUY PIECES OF COLOURED GLASS AT HALF-PRICE. THESE
COLOURFUL TRANSLUCENT SLIVERS MINGLE PRETTILY WITH DEAD LEAVES,
FROST AND EVEN SNOW IN WINTER.

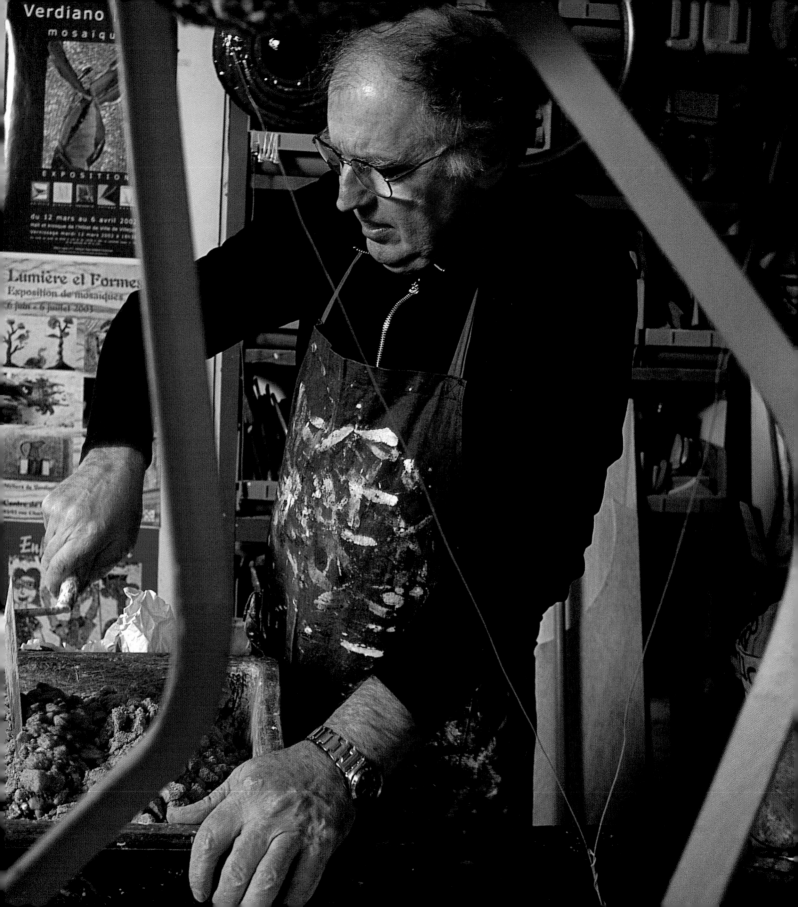

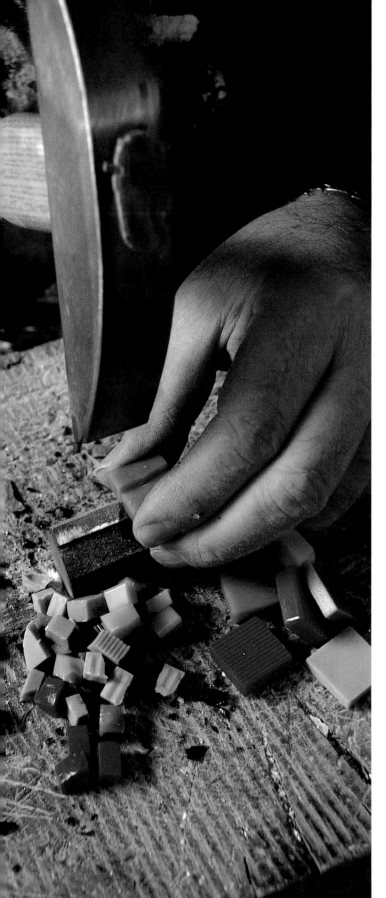

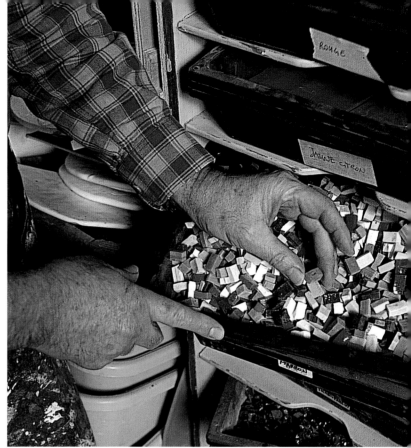

PROCEDURE

YOUR MOSAIC, THE UNIQUE PIECE YOU CREATE, WILL COMPRISE INDIVIDUAL STONES ARRANGED SIDE BY SIDE IN A BED OF MORTAR OF VARIABLE THICKNESS. BUT THERE IS MORE THAN ONE TECHNIQUE FOR DOING THIS, DEPENDING ON THE INTENDED APPLICATION. TRY OUT EACH PROCEDURE, GRADUALLY LEARNING THE RULES OF MOSAIC WORK UNTIL YOU KNOW THEM BY HEART. ONLY THEN CAN YOU MOVE ON AND INVENT YOUR OWN CREATIONS.

1

BASIC
TECHNIQUES

PREPARATION

Coming up with an idea

The creative process can be sparked off by anything at all – a fleeting glimpse when you are out on a walk or something you have picked up from the pavement. Verdiano Marzi's studio is crammed with objects he has found dumped or discarded, or on wasteland. For the mosaic artist, anything may stimulate the imagination, and items he comes across by chance in everyday life act as a source of inspiration or visions. He falls upon such treasures, gives them a thorough clean and puts them alongside the other materials already stored in his studio. Often just setting a specific shape next to a glass tile will give him an idea. Verdiano Marzi makes the base, mounts the materials he has salvaged and then decorates this structure with mosaic. He preserves these materials by breathing new life into them, helping their beauty to burst forth again after they have been discarded. He now invites you to join in this process.

Design, choice of materials and making the base

Whether an idea comes to Verdiano Marzi gradually or in a burst of inspiration, he always draws a design for his project. You should do the same, setting out its forms, proportions and colours on paper.

This drawing will help you determine the outline of your object, as well as its proportions and the motif of your mosaic. It will guide you when it comes to making the base and creating the mosaic itself.

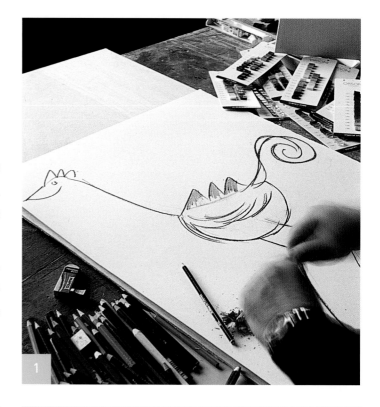

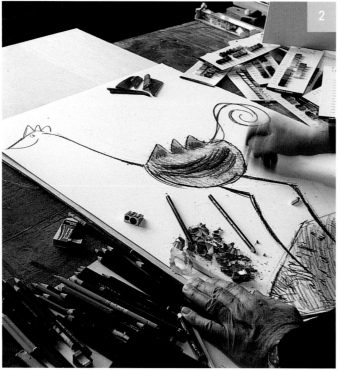

1 and 2. Verdiano Marzi hit upon the idea of making a sculpture of a bird for the garden when he spotted angle steel and concrete reinforcement bars lying around outside. Just as he did, sketch out the legs, body and neck, decide on the proportions and draw the lines and curves of your object. Use coloured pencils, not felt pens, however, so you can blend the colours together.

3, 4 and 5. Start assembling the glass tiles and pebbles, granite and brick that you will use to cover the body of the bird in the mosaic.

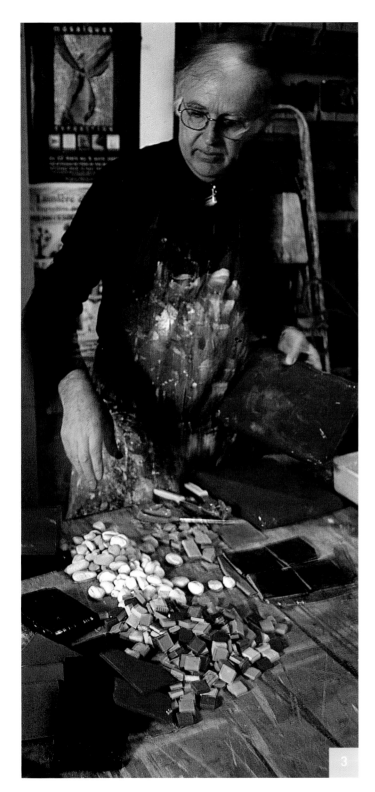

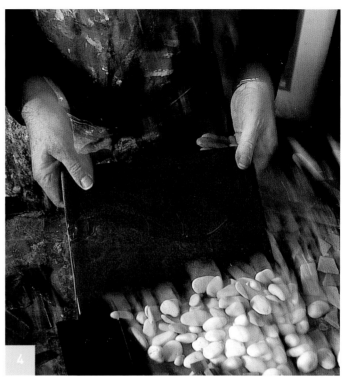

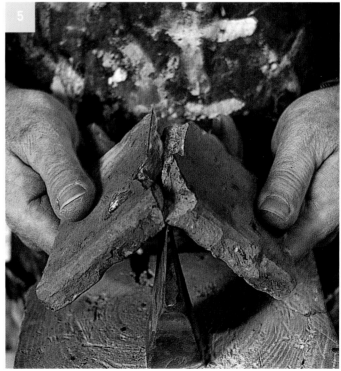

DESIGN, CHOICE OF MATERIALS AND MAKING THE BASE

You will use a range of materials to make this mythical bird, with its dinosaur-like profile: angle steel and concrete reinforcement bars for the legs, neck and head; and wood and polystyrene for the body, the middle part of the bird.

Start off by removing the rust from the metal with sandpaper. If you are using new materials, you can make them look old with the help of vinegar or acid.

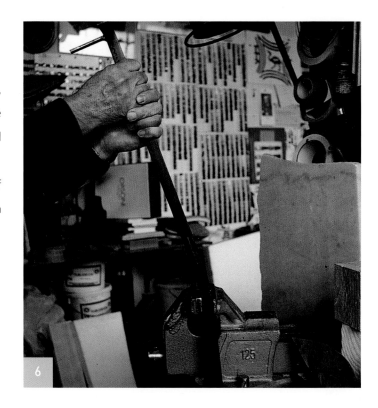

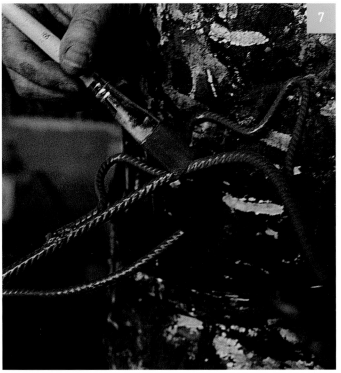

6. Take a saw designed for cutting metal and cut a few centimetres off the bottom of two pieces of angle steel to make the legs. Use a vice to shape the steel for the feet and the bars for the head and tail. Choose bars with two different diameters, using the thicker diameter to make the neck, beak and tail. The smaller bars are used for the crest on the head.

7. Join the crest to the beak and then apply rust preventer to the head and legs. This will take around 6 hours to dry, depending on the make. Apply a second coat after 24 hours.

➔ *Use gloves when applying the rust preventer and select the colour with care, as it will be visible when the sculpture is finished.*

8. Draw the body of the bird on to a piece of plywood about 2cm (¾in) thick. Cut the shape out with a jigsaw, keeping the offcuts to use later on.

9. Prepare the plywood for the attaching of the angle steel using a drill, pincers, bolts and metal washers. First fix the plywood offcuts in the middle on both sides to create volume for the wings; then attach the angle steel to this part of the body. Bend the legs to make the bird look as if it is walking along.

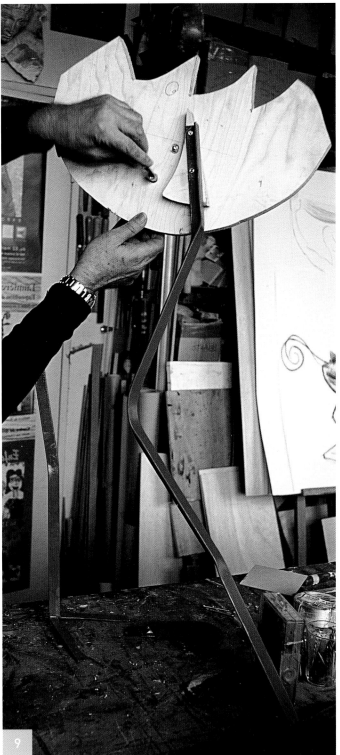

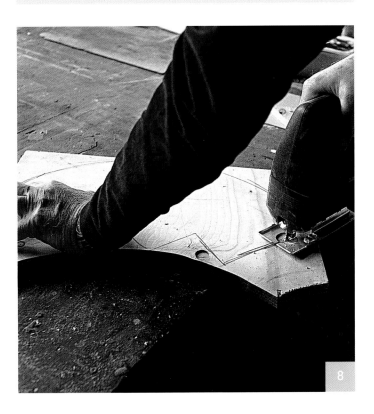

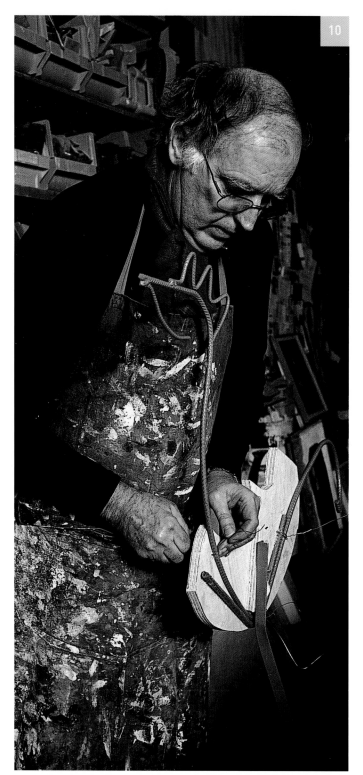

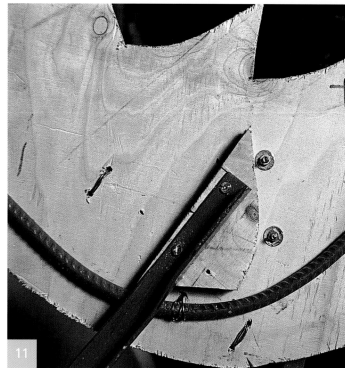

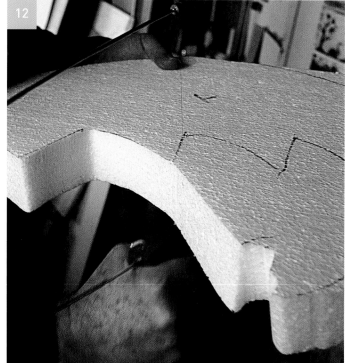

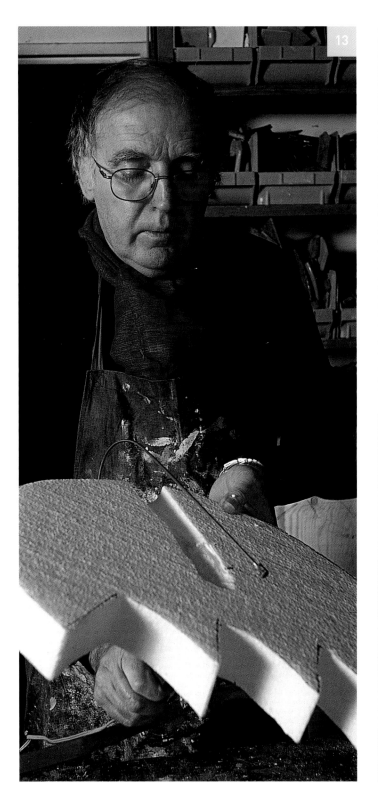

10 and 11. Join the bars (neck and tail) to the belly using galvanised wire, a drill and pliers.

12. Use cutters, preferably with a hot wire device, to cut out two pieces of polystyrene matching the shape of the body.

13. Hollow out the polystyrene so that it can be fitted on to both sides of the structure you have built. Round off the edges of the polystyrene to give the body of the bird a curved shape.

14. Glue the polystyrene to the wood using special adhesive for polystyrene or tiles.

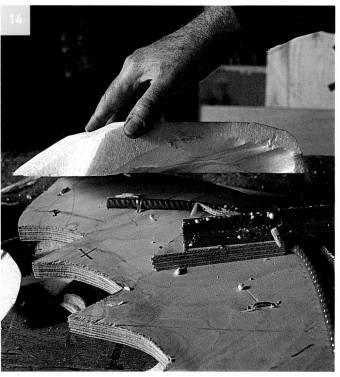

Tile cutting

You will use different tools to cut the tiles to size depending on the materials involved. You will gradually explore their hidden beauty at each stage of the process. This is what Verdiano likes best: discovering the inner light of his materials. He often starts to dream when revealing the hidden secrets of pebbles, for example – the sparkle that has been concealed for millions of years and never been seen by anyone. He feels privileged and profoundly happy to be able to bring such magic to light thanks to mosaic.

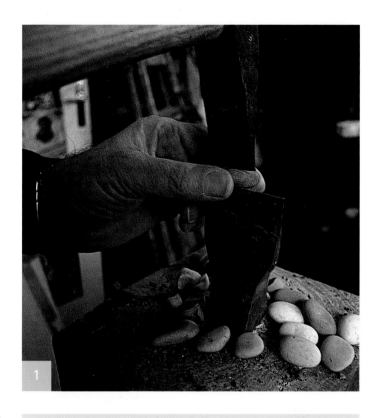

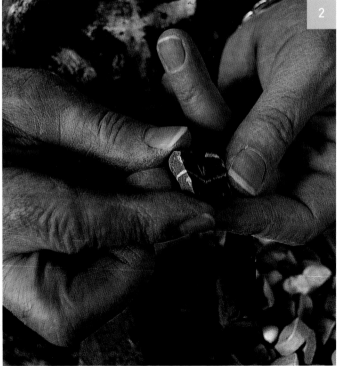

1 and 2. Cut the pebbles by placing them on a hardie fixed to a block of wood and striking them with a mosaic hammer. Make sure you cut them cleanly, keeping the hammer horizontal. Unpredictable stresses may sometimes make the stone resist or even shatter. Follow Verdiano's method: do not try to break the pebbles up into tesserae but cut them in a way that preserves their rounded shape.

Vitreous glass

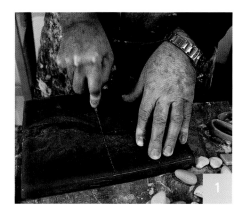

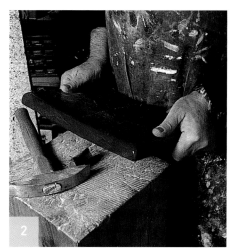

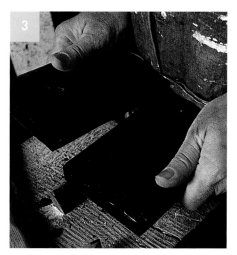

1. Score a line on the slab of glass by pressing down hard with tile cutters.

2 and 3. Tap the glass on the hardie and it will split along the line drawn with the tile cutters.

➔ *If the slab refuses to break, or even shatters during this step, this is due to a production defect.*

4. Continue dividing up the slab with the cutters, then striking with the hammer held slightly at an angle. Make clean blows using the edge of the tool. Do not apply too much force; the weight of the hammer falling on the glass will be enough to break it.

Keep cutting the slab down into smaller and smaller pieces until the sides measure about 7mm (¼in). Pick up the fragments carefully, without pressing too hard, or you will hurt yourself. Don't forget that glass can cut!

Ceramic tiles are cut using a mosaic hammer or tile nippers.

➔ *Use goggles when cutting tiles to protect your eyes from splinters.*

➔ *One slab will produce around 1600 tesserae. Make yourself comfortable before starting on this lengthy process.*

➔ *When you have finished, put the cut pieces in a metal box such as a metal biscuit tin. Give them a good shake to smooth off the sharp edges so nobody cuts themselves later on, and then take out and discard the glass dust. Put the tesserae away in dishes or trays, organising them by colour.*

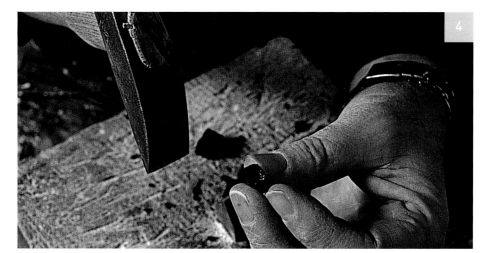

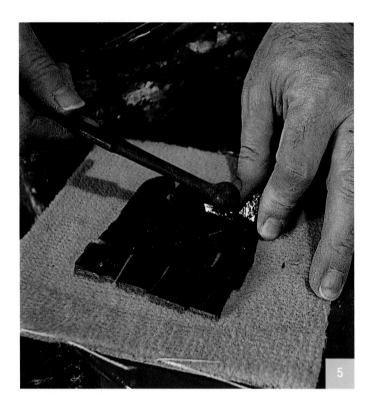

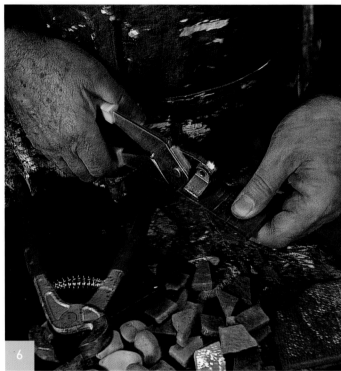

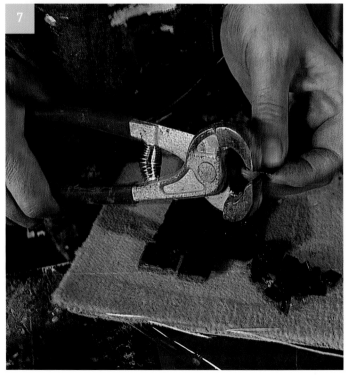

5. When using the much thinner glass tiles, use tile cutters to divide them up into sixteen squares and break them by tapping along the lines scored with the cutters.

→ *Use an old piece of carpet to absorb the impact.*

6. You can also use tile cutters of the type used by professional tilers to break up these tiles along the lines scored with the cutters.

7. Cut up the tesserae with tile nippers.

Marble, granite and brick

1. Cut the slabs of marble with a hammer or mosaic hammer on a hardie set as high as possible. Make the tesserae by striking cleanly. Hold the mosaic hammer at a slight angle, as when cutting glass, and hit the marble with the edge of the tool.

The resistance will vary depending on the type of marble. Unlike pebbles, which are rather unpredictable, marble remains constant in its behaviour, as marble masons and mosaicists know. This pink marble from Portugal, for example, will break cleanly if you follow the direction of the veins, but cutting across them is harder. Handling this Portuguese marble, which is just as temperamental and stubborn as green marble from the Alps or Rosso Levanto marble from Italy, is not easy, but Verdiano uses it frequently as he likes its magnificent smoothness.

2. Make sure you use a regular hammer for granite, for example when cutting this Blue Bahia granite, or you will damage your mosaic hammer.

3. Break brick tiles by striking against a hardie set as high as possible, as used for marble. Gradually reduce the pieces in size using a mosaic hammer with a head of hardened steel until you end up with tesserae.

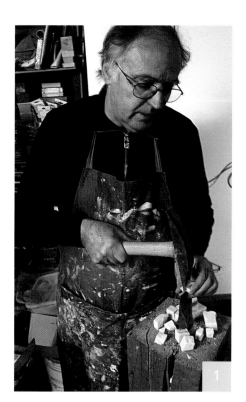
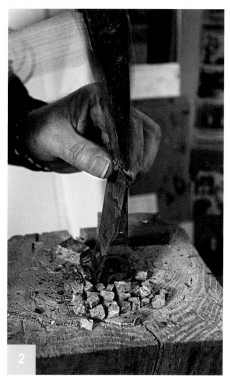
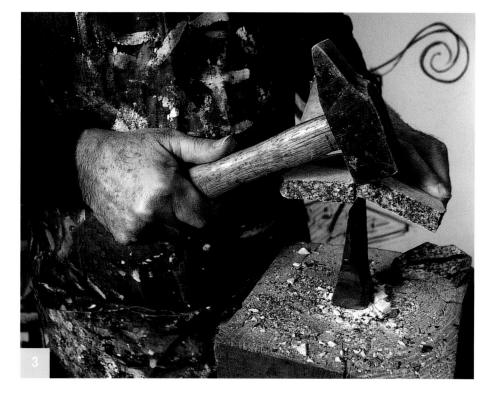

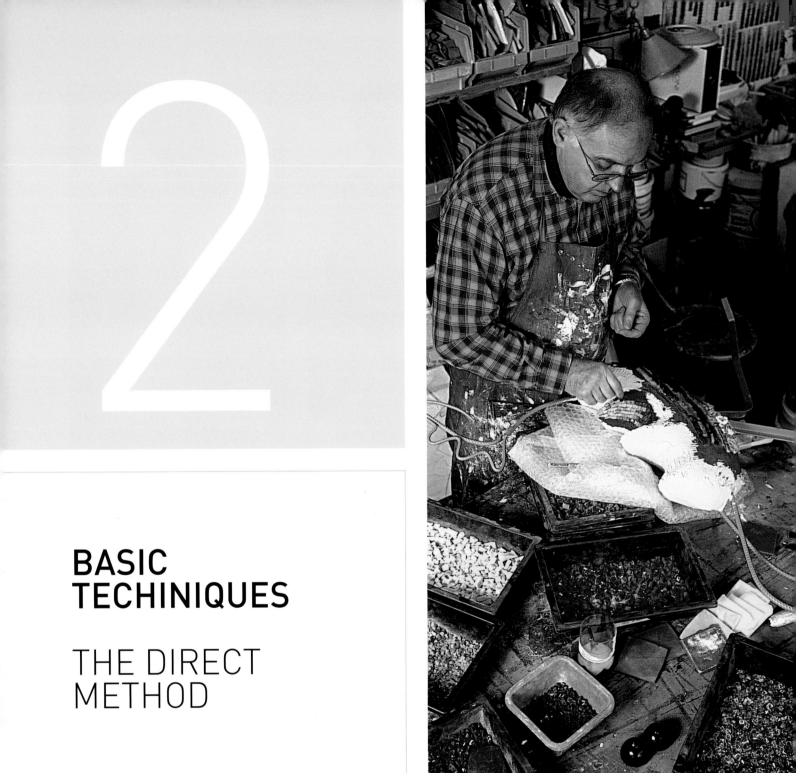

2

BASIC TECHINIQUES

THE DIRECT METHOD

Direct mosaic work

Once you have made the base, you decorate the bird with mosaic using the direct method, which consists of lining up the tesserae in fresh mortar or the setting bed. As you work, the mosaic gradually takes shape before your eyes. This direct method is suitable for flat surfaces or 3D objects, including mirror borders, boxes, bowls, vases, ashtrays, seats or floors. If you are making a mosaic floor, ensure you create a level surface with no undulations by using tesserae of the same thickness. Finish off by sanding down at the end.

Verdiano Marzi often uses the direct method, as it gives him more scope to use his imagination while he is working. Contrary to general belief, mosaic is not a jigsaw. The artist does not embark on a mosaic with a fixed goal in mind; he is actually going through a creative process, discovering his work of art as he goes along.

Verdiano compares a mosaic to a desert that has to be populated, or filled in. The task of laying the pieces is something akin to alchemy, and is in no way a mechanical process. The initial design – a mere outline yet so essential to the process – is just a starting point for the artist's work.

Mortars

It is the combination of the tesserae and the grout that makes each mosaic look as it does. The fragments of material used and the grouting interact to produce a broken, disjointed impression, yet nevertheless contribute to the emergence of a whole. The setting bed containing the tiles is applied over an initial layer of mortar in a neutral shade. This is designed to strengthen the base and protect it from moisture.

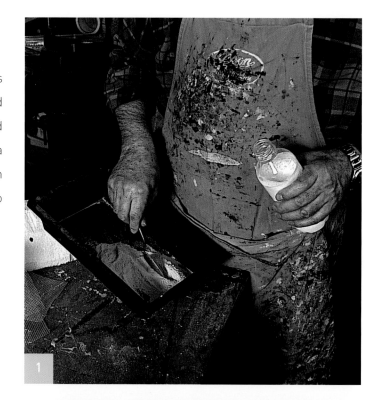

BASE MORTAR

1. This initial mortar is made up using Kerabond (tile mortar) and Mapei Isolastic (a flexible latex additive), which has been diluted (one part Isolastic to two parts water). Mix until you have a thick paste.

2. Apply an initial layer of uncoloured mortar. Add pieces of glass-wool mesh to act as a key and reinforce the base. Allow this base mortar to dry for at least 48 hours.

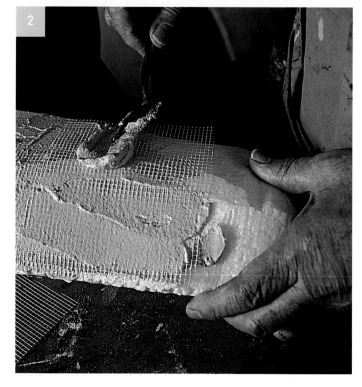

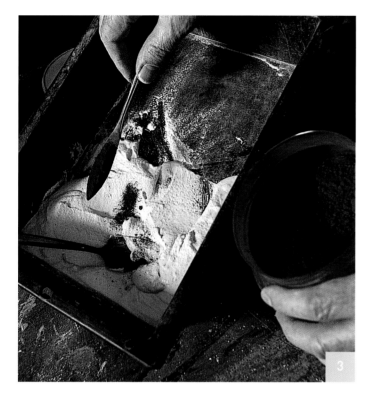

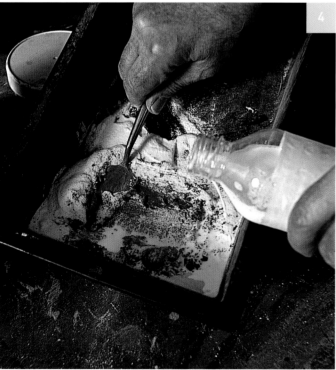

UPPER LAYER OF MORTAR, OR SETTING BED

3. Use a spatula to mix Kerabond and diluted Isolastic (one part Isolastic to two parts water) in a small trough to produce a soft, supple paste. If you wish to have coloured grout between the tesserae, add a colouring agent.

→ *This colouring agent should not make up more than 15% of the mixture or you risk weakening it.*

Mix up the Kerabond and colouring while dry, before adding the Isolastic.

4. Gradually add the liquid Isolastic to the dry mixture (Kerabond and colouring). Work with the spatula to produce a smooth, supple paste. Before applying this second layer of mortar, wash over the area you are going to work on with Isolastic. Apply a 4–5mm (approx. ¼in) thick layer of mortar with the spatula and mould it with the flat part of the tool. It should be as smooth as possible, a bit like butter. With the tip of the spatula, outline the positioning of the tiles or the contours of the mosaic.

→ *You can use mineral oxides or powdered terracotta to colour the grout. The choice of colour depends on the materials you are using for the mosaic. You can stick to the same colour scheme as the mosaic or opt for a contrasting shade. You can also use grouts of different colours in one mosaic to set off the colours of the tesserae.*
The interstices (the gaps or joints) between the tiles will become more or less obvious according to the colour of the grout. Generally speaking, the lighter the colour, the more apparent it will be; the darker it is, the more it will blend in. Note: Colours become lighter as they dry.

Laying tiles

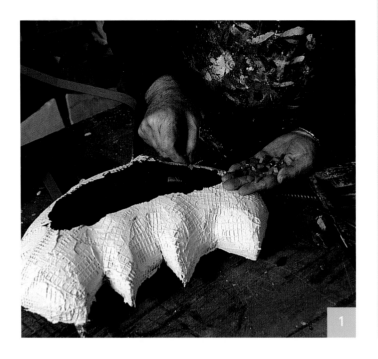

1. Keep both your fingers and the tools you are using absolutely clean or you risk spreading mortar on the side of the tiles that will be visible. At the Ravenna Academy of Fine Arts where Marzi trained, messy work was not permitted. Students had to remove all the tiles and start again from scratch.

Once all the tiles have been laid, the entire mosaic must be clean. One of the most important rules of this profession is that it should not be necessary to clean the tiles, as the abrasive products required to do this will cause the mosaic to lose some of its sparkle.

2. Lay the tiles one by one, working over small areas at a time and without applying too much mortar. Each tile should be pressed into the bed until only one third remains visible.

→ *Once you have finished a section of the mosaic, tap the tiles you have just set to level off the surface of the mosaic and allow the mortar to rise in the interstices. This operation is a bit tricky as you risk making the tiles dirty. Proceed with a light touch; you will gradually acquire the skill needed here. This way you will prevent rainwater from gathering in the joints and you will protect the sculpture from getting cracked by the frost when it stands outside.*

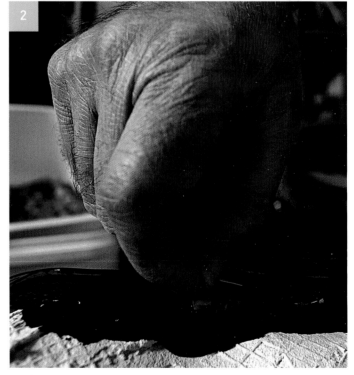

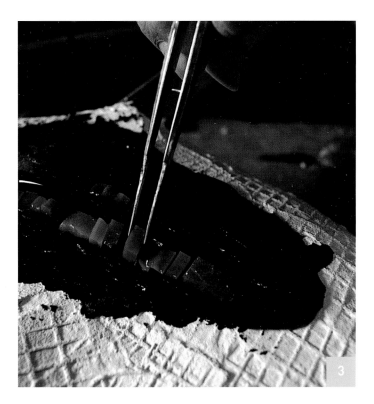

3. If you are not happy about the shape or colour of a tile you have just laid, you can use a pair of metal tweezers to remove it again.

4. Cut down tiles with the tile nippers if necessary.

→ *Arrange the trays of tiles within easy reach and adopt a comfortable position at the workbench. This will help you feel less tired and make sure you enjoy yourself whenever you are working on your mosaic.*

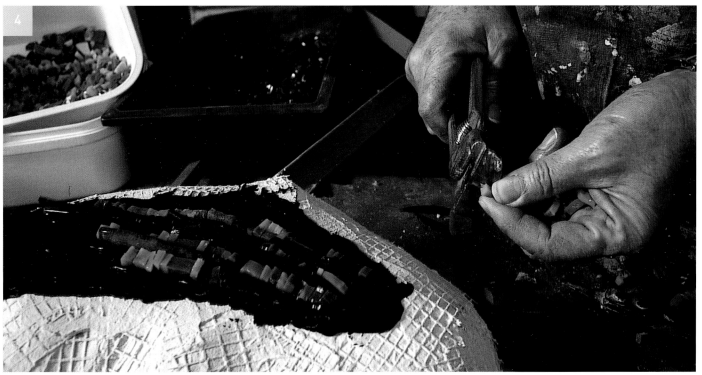

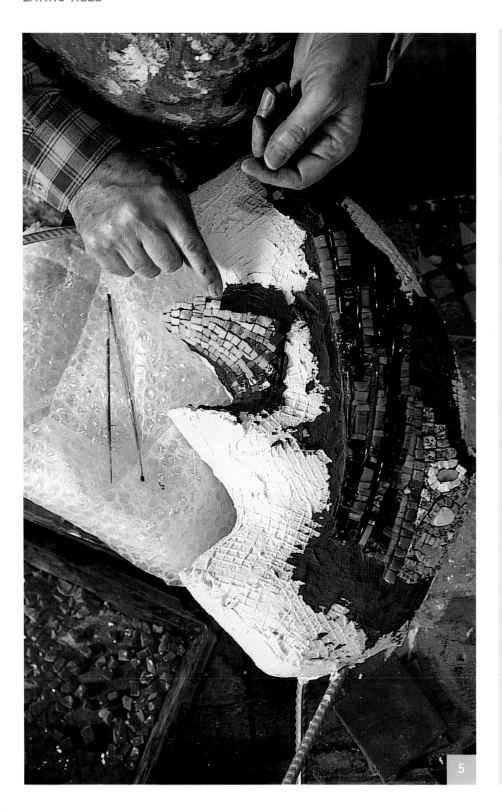

5

5. When laying the tiles on the crest on the bird's back, start at the tip and then move down towards the belly. Use a dark colour mortar that will blend in when the mosaic is complete.

→ *Create shading within a single colour, for example by combining different yellow tones: straw, lemon, daffodil, buttercup, etc.*

→ *If you cannot find the right tile among the batches you have prepared, cut up a new slab of glass or marble. You are free to change your initial design, as new ideas will come to you as you work. They may well improve this design, which is really just a guide. If you find you prefer to do something different as you go along, welcome your new idea and put it into practice.*

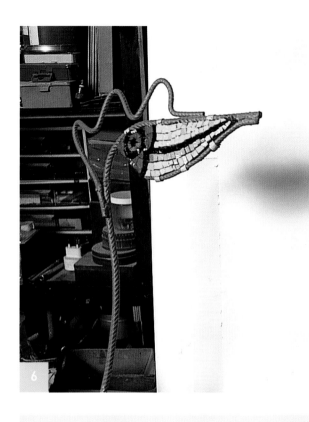

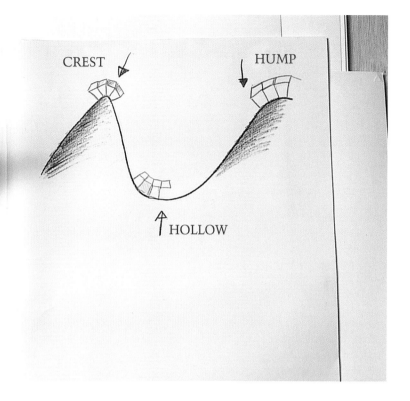

CREST HUMP

HOLLOW

6. In the hollows, use little rectangular tiles as shown in the sketch. Use fine tweezers when laying tiles in narrow spaces or dips.

7. At the tips use a tile that is round or almost trapezoidal in shape, arranging very fine, triangular tiles around it.

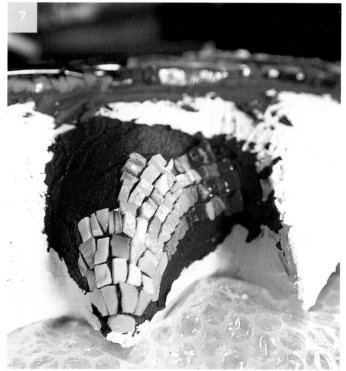

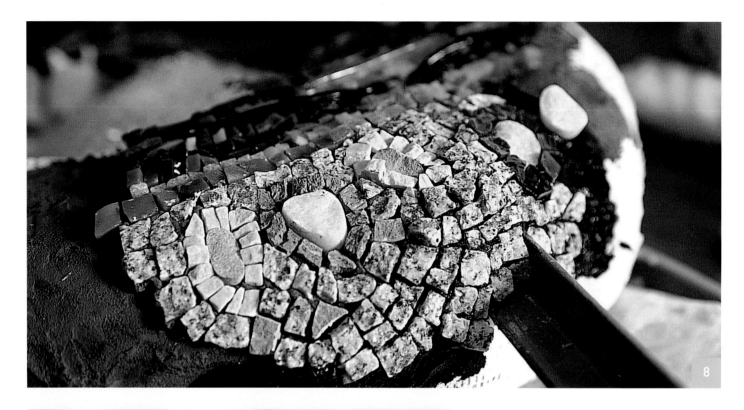

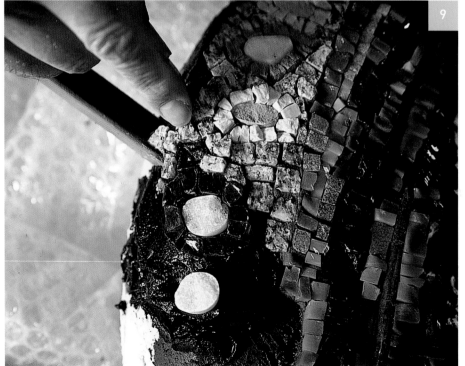

8 and 9. Lay tiles around the legs and tail. Do not glue tiles to the metal or they might drop off should the legs and tail move. Leave a gap of 2–3mm (approx. ⅒in). Continue laying the tiles, moving over the belly and towards the wings, joining up these sections as you work.

→ *If the base layer of colourless mortar has gone lumpy around the legs and tail, clean and scrape off any unevenness before applying the second, coloured, layer of mortar.*

When you have finished one side, allow it to dry and then work on the other side, putting bubble wrap underneath to protect the mosaic you have already completed. If you want to take a break – at lunch time for instance – cover the fresh mortar with a piece of plastic or rag and put a board on top to stop it drying out. When resuming work, dampen the base layer with a brush dipped in diluted Isolastic and then apply the coloured mortar.

When you finish work for the day, use the spatula to remove any excess mortar which has not yet been covered with tiles. Do not allow it to harden or this will produce an extra layer of thickness underneath the new mortar you apply next time round.

→ *Do not forget that slow-setting mortar will allow you to work for several hours – but once it is dry, it has set for good!*

Before putting away your spatula and tweezers, clean them by scraping off any mortar adhering to them. Clean the bowl by scraping it out with a spatula and rinsing it with water. Dilute the dirty water thoroughly and discard it in the WC (not in the sink, or the mortar will block up the drains when it hardens).

→ *If a tile comes off when you move the mosaic a day or two later, use fresh mortar and a drop of Isolastic to glue it back on, taking care not to make the adjacent tiles dirty. If it happens a few months after completing the sculpture, glue the tile (or a similar one) back on using Araldite or a similar strong adhesive.*

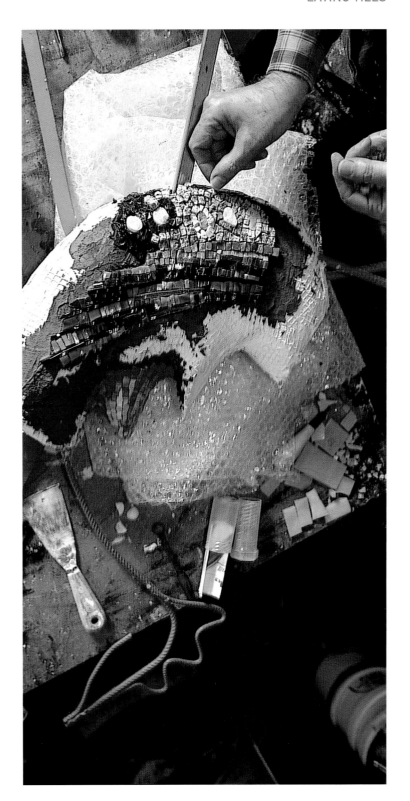

3

BASIC
TECHNIQUES

THE MESH
METHOD

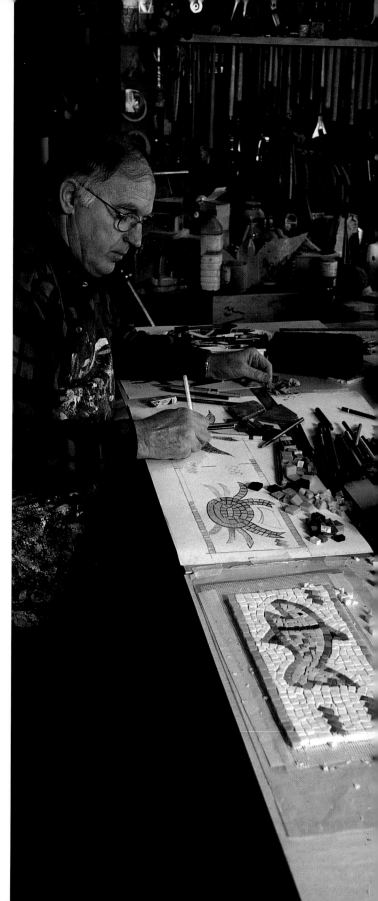

Example of a frieze

The mesh method is a variation on the direct technique. By using a mesh, you can see the design as you work, but you are not making the mosaic *in situ*: it is created in the studio and then transported to its final destination. You can use this procedure for friezes to decorate your kitchen, bathroom, holiday apartment or even for your friends' homes if you are after an original gift. This method allows you to create borders for tiling or individual motifs that can be set between tiles on the floor or walls.

If you wish to make a tiled floor, follow the procedure described below, just increasing the thickness of the mortar and tiles. Make sure that your mosaic is laid on a firm base and is nice and smooth.

You can find examples of antique friezes in the two-volume catalogue *Décor géométrique de la mosaïque romaine* (published by Picard, Paris, 2002). This publication shows the motifs as drawings; this means you have to copy them to recreate the arrangement of the tiles. If you are interested in something more up-to-date, you can look at Hélène Guéné's book about Isidore Odorico, one of the great mosaic artists of the Art Deco period (published by Archives d'Architecture Moderne, Brussels, 1991) or *L'Art de la mosaïque* by Giovanna Galli (published by Armand Colin, Paris, 1991), which covers all periods.

Verdiano Marzi suggests you try out the design of a fish that was inspired by an antique mosaic. This motif can be repeated along a wall or just used once on its own.

1. Photocopy the motif, adjusting the size so that it fits on to a standard tile measuring 15 × 30cm (6 × 11¾in) and can be installed on a tiled wall without any problems. Use a felt pen to copy the design on to glassine paper.

2. Fix this paper to a board to act as your work base and protect it from moisture by covering it with a thin sheet of Rhodoïd (acetate).

3. Cover the drawing with a piece of glass-wool mesh. Tape all the layers down to stop them slipping.

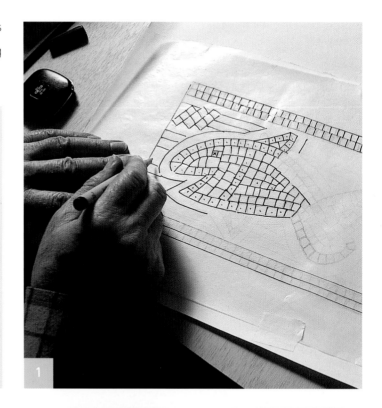

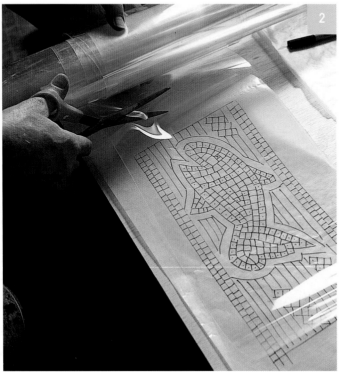

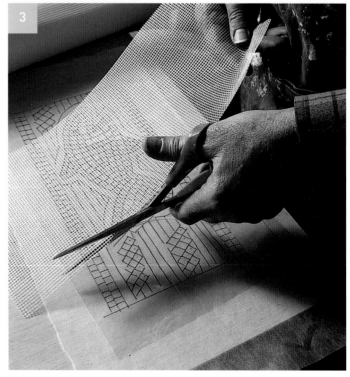

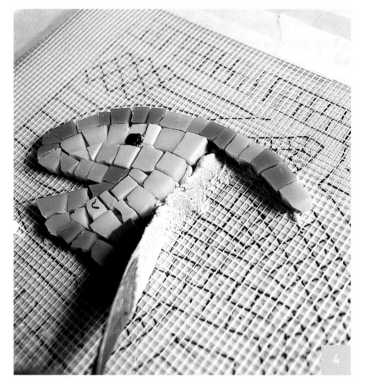

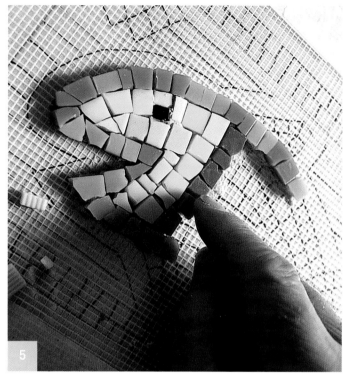

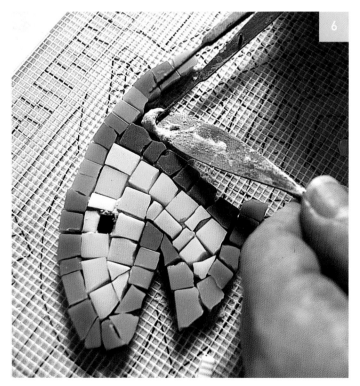

4, 5 and 6. Lay the tiles (ceramic tiles in this example) on the mesh which you have already coated with transparent adhesive. Alternatively, you can use a mortar produced by mixing Kerabond with Isolastic. In this case the Isolastic should not be diluted, in order to improve the behaviour of the mortar.

Create a flat smooth surface. If you are using pebbles, place the rounded part uppermost. This prevents any risk to people using the room where the frieze will be installed.

➔ *If you do not manage to finish the mosaic in one session, remove the mortar from the area you have not covered with tiles before finishing work.*

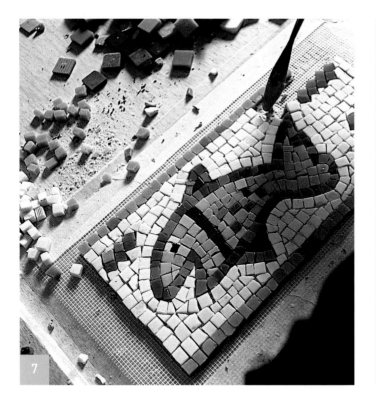

7

7 and 8. The movement of waves is shown by using tiles cut into triangles.

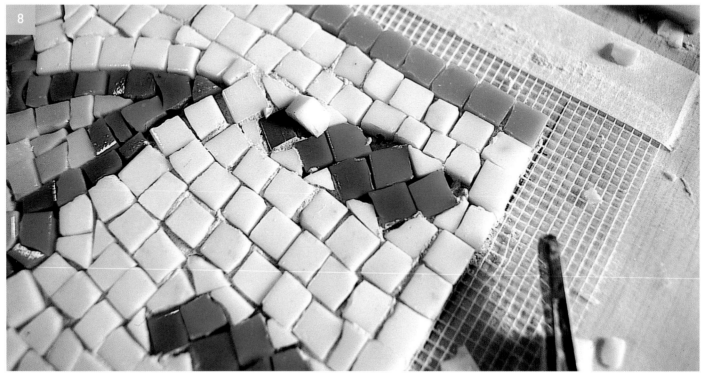

8

9. Use a pair of tweezers when working on areas of the mosaic that are tricky or a bit small.

10. Once you have finished your mosaic, you can repeat the design in a continuous line or think up other 'fishy' motifs to create a border or to use as decorative features arranged over a wall.

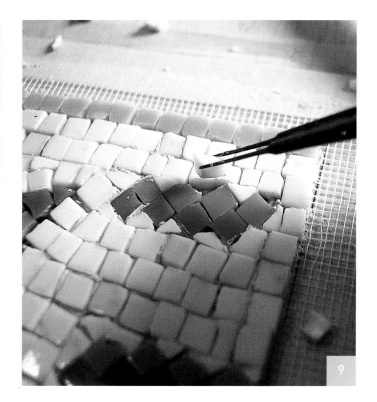

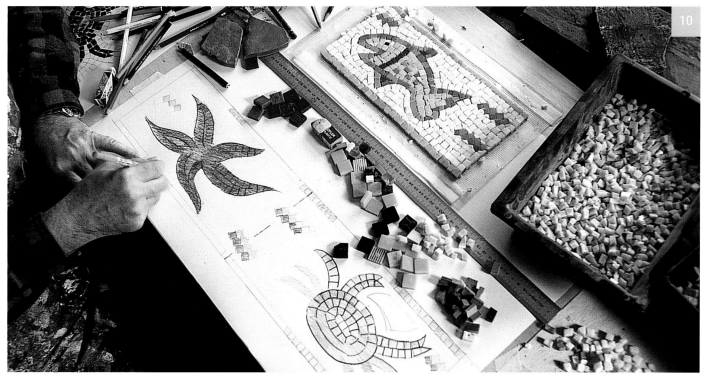

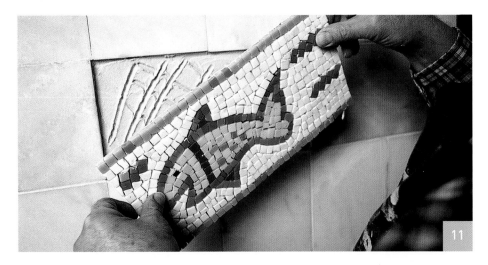

11. Apply mortar to the wall where the mosaic is to be installed as well as to the back of the mosaic held together by the mesh. To produce this mortar, mix together three parts of Kerabond to one part of diluted Isolastic to create a firm paste that is not too liquid. Use the point of the spatula to cross-hatch the mortar on the wall and the back of the mosaic before fixing it in place.

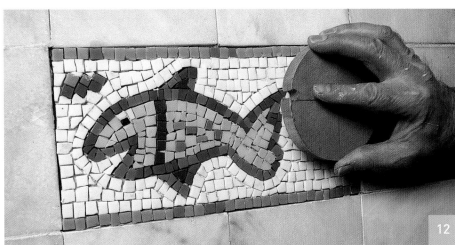

12. Tap the mosaic with a piece of wood to strengthen the bond between the two surfaces. The mortar may squirt out while you are doing this: this means it is adhering well. Wipe off any excess with a damp sponge.

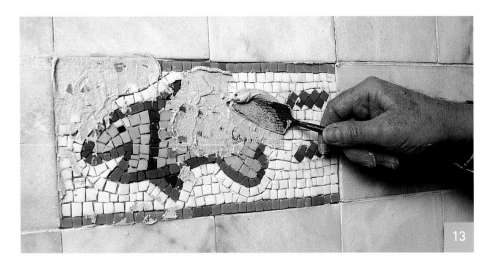

13. Cover the mosaic with tile grout using a trowel. Here Verdiano Marzi is using white grout but he could just as well have chosen blue. Match the colour of the grout to the colour scheme of your mosaic in the way that you prefer.

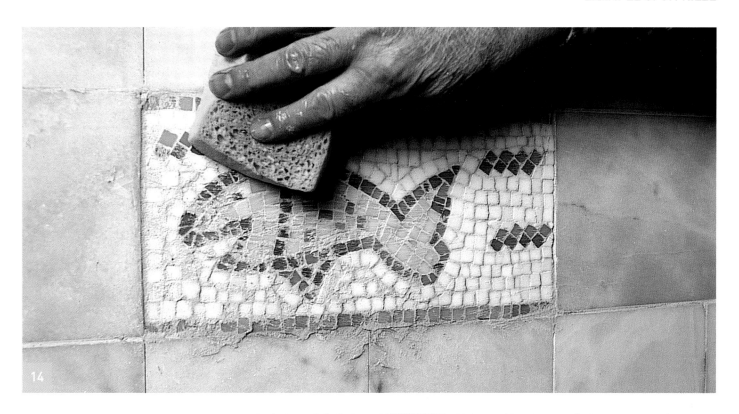

14

14 and 15. As soon as you have finished working on the joints, use a damp sponge to clean the mosaic. Place a bucket of water next to you and keep washing until the grout disappears. Allow to dry for 48 hours.

→ *If you notice a hollow between the tiles after you have wiped off the grout, re-apply grout and sponge off again.*

→ *If the mosaic looks dull after being wiped down, you can wash glass tiles with a very weak solution of distilled vinegar and water. But do not use this trick on marble, as vinegar will damage it.*

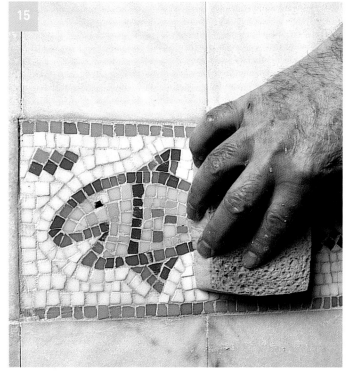

15

4

BASIC TECHNIQUES

THE INDIRECT METHOD ON PAPER

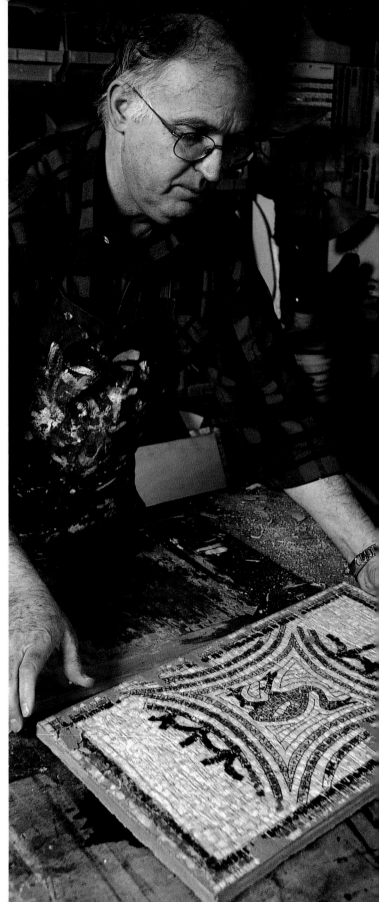

Reproduction of an antique design

The 'reverse mosaic' method, which was invented or reinvented by Giandomenico Facchina, allows the artist to reproduce a motif with great accuracy. This indirect method consists of gluing the face of the tile that will be visible at the end of the process down on to paper. When laying the tiles, you thus only see the back of each tile. The mosaic is then turned over and the tesserae are pressed into a bed of cement so that they are fixed in place and no longer visible. The right side of the mosaic is only revealed at the end of the process, once the paper has been removed.

Unlike the direct method, during this process the mosaic is not attached to its base, which gives you greater freedom when organising your work. The indirect method allows you to proceed at your own pace, working on several mosaics at one time – tabletops, perhaps, or pictures in mosaic. On the other hand, when creating the actual mosaic, you should always keep to the design you have drawn. It is not just a guide in this case but a model for execution.

You can find examples of antique designs in books about mosaics, such as *Sols de l'Afrique romaine: mosaïques de Tunisie* (published by Imprimerie nationale, Paris, 1995) and, in particular, *Mosaïque: trésor de la latinité* (published by Ars Latina, Paris, 2000). This is a very comprehensive work that covers all periods and geographical areas and also includes works dating from the twentieth century.

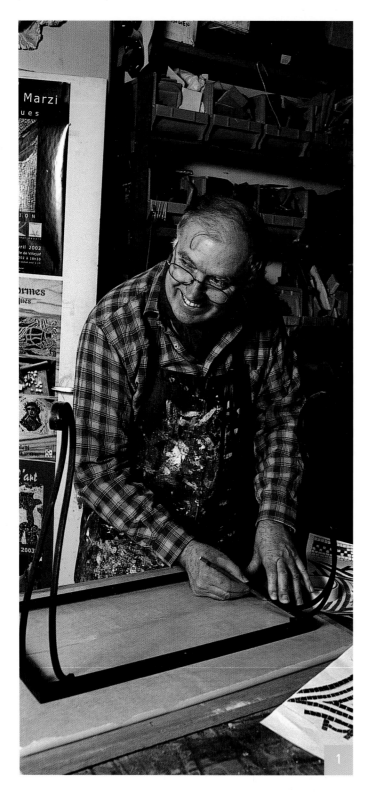

1. Select a design (from a book, photograph or postcard) and photocopy it in black and white or colour. The size will depend on the final purpose of the mosaic. Here Verdiano Marzi has decided to decorate a coffee table with a detail from the floor of a second-century Roman villa built at Rimini in the Emilia-Romagna region, on the Adriatic coast. Copy the way he works: measure the table carefully and position the motif in the middle of the tabletop.

2. Draw the outlines of the object on the photocopy and add the tiles one by one using a permanent marker pen.

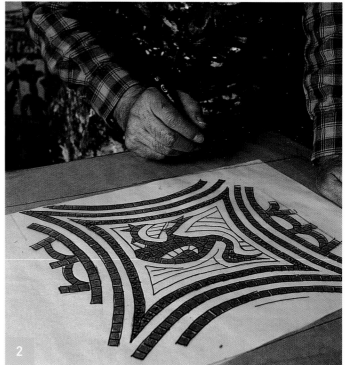

3 and 4. Tape the design to a wooden board placed on your worktable and cover it with a piece of glassine paper. This type of paper is ideal when using the indirect method as it is fine, transparent and flexible. This is why Marzi prefers it to tracing paper or kraft paper, which are sometimes used for this purpose. With a felt pen, copy the design and arrangement of tiles on to this sheet of paper.

Draw a pattern around the central motif of the design as a border for the table. Here Verdiano is using a geometric pattern. If your design features several colours, choose a code to represent them and mark each tile accordingly (e.g. a dot for black, an 'x' for ochre, etc.). If you are using a lot of different colours and your design is complicated, colour coding will be a great help in your work.

Once you have finished this task, remove the photocopy and the glassine paper. Put a sheet of white paper on the wooden board to make things clearer when you are laying the tiles. Position the glassine paper on the white sheet, turning it over if you want to have the original design the right way round.

→ *Tape the glassine paper to the white sheet to prevent tiny pieces of tile from slipping in between the sheets. If this happens the little bumps will stop the paper lying flat when you are laying the tiles.*

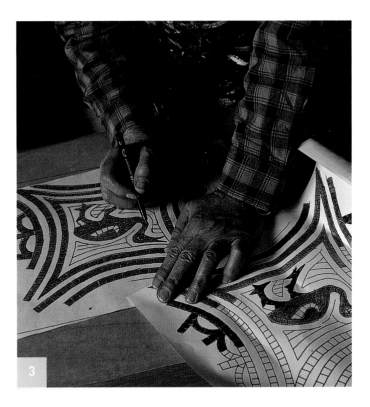

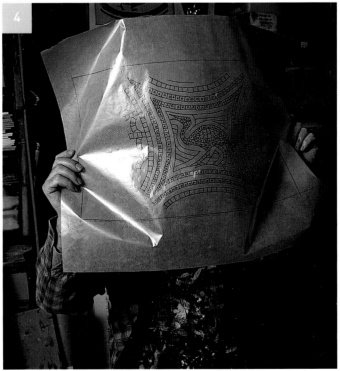

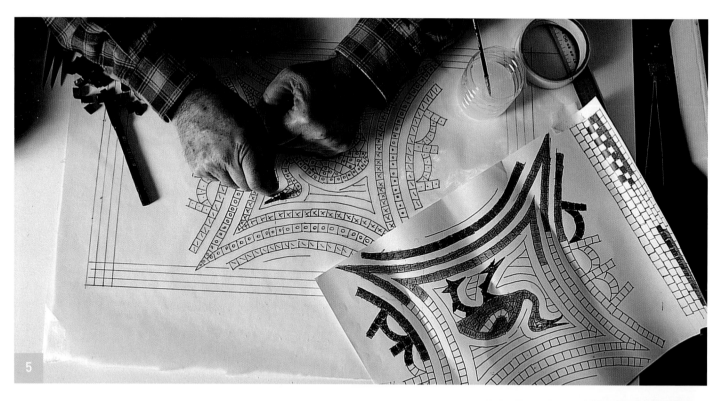

5 and 6. When laying the tiles, start at the central motif and work outwards, keeping to the squares drawn on the paper. This will also be a help when cutting the tiles to size.

Use a fine paintbrush to apply wallpaper paste diluted in water to the part of the mosaic you are going to decorate, and make sure you keep to the mixing ratios specified by the manufacturer. Place each tile in the area you have prepared or, alternatively, coat each tile with adhesive before setting them side by side. Make sure you leave a tiny gap between each one.

→ *Do not forget that it is the face of the tile stuck to the paper that will ultimately be visible in the mosaic! You should therefore keep track of the colour of the hidden face of the tile. This also applies to the surface, which has to be nice and flat – something that is not essential for the back of the tiles (i.e. what is visible while you are working).*

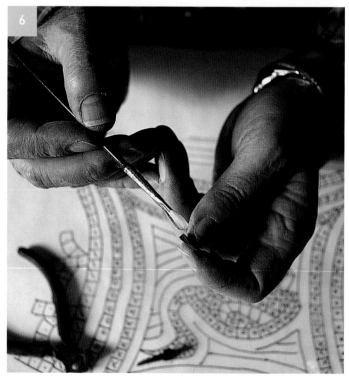

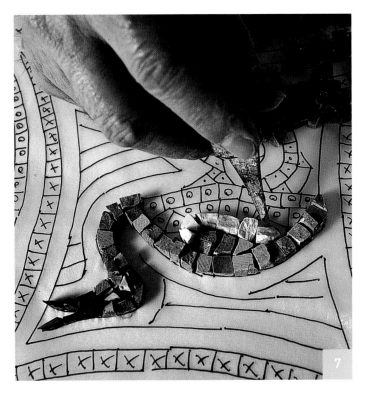

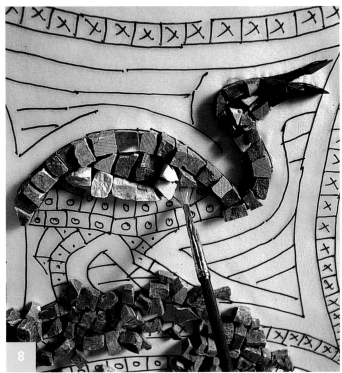

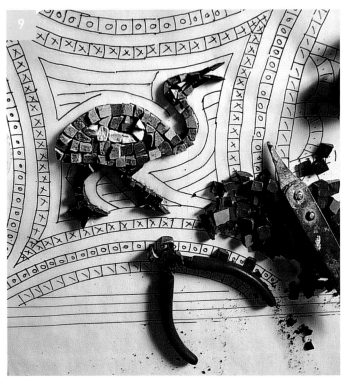

7, 8 and 9. Cut the marble with the hammer, adjusting the size with the hardie and nippers as you position the tiles in the mosaic.

For the beak, cut small tiles measuring 4–6mm (approx ¼in).

→ *Remember that the adhesive is slow to dry. It will take several hours for the tiles to stick to the glassine paper properly. While you are working, take care you do not dislodge the tiles you have just laid.*

→ *Whenever you stop work on the project, leave the mosaic in place on the board and cover it with a piece of paper or a rag.*

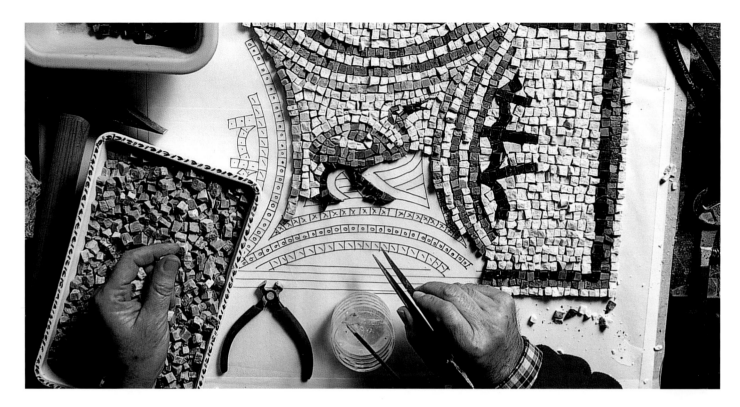

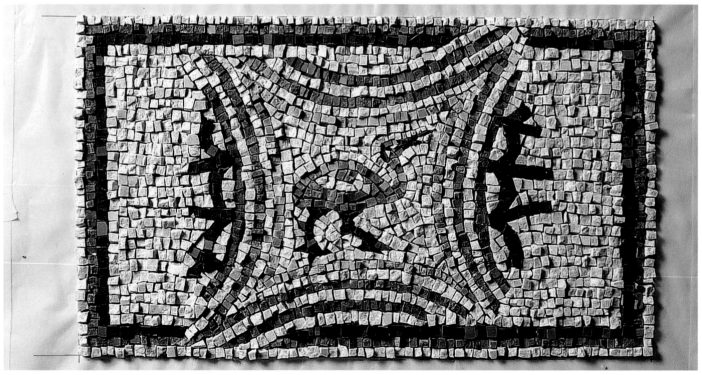

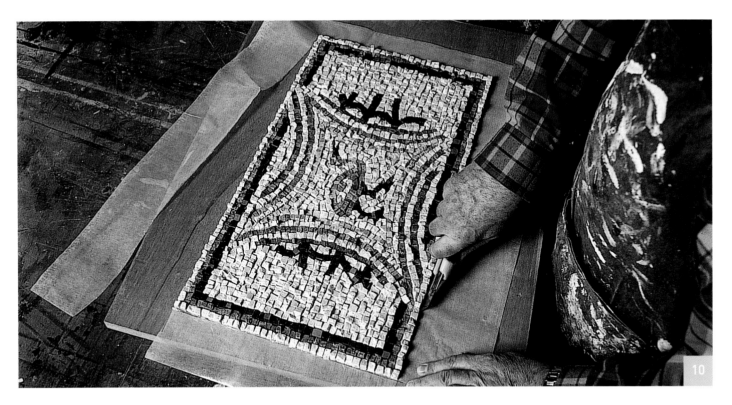

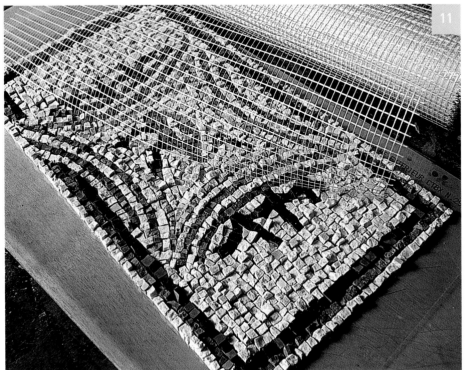

10. Once you have completed your mosaic, move it on to a Formica board or piece of wood that is waterproof. Use the cutters to reduce the sheet of glassine paper to the size of the mosaic.

→ *Protect the piece of wood supporting the mosaic with a sheet of Rhodoïd if the material of your base is not waterproof.*

11. Cut a piece of glass-wool mesh to match the dimensions of the mosaic to which the cement will be applied.

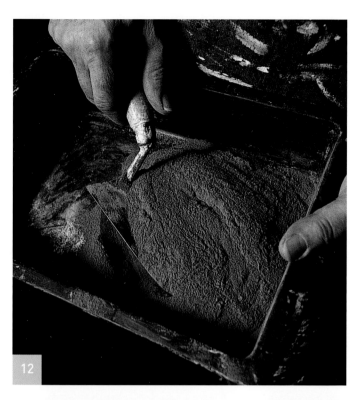

12

12. If terracotta is added to the mortar, it will give an antique look to the mosaic. Choose a type that is very fine (diameter 0.1mm) to make sure it will get right into the joints. Take a container and mix up the powder with water.

13. Fix the mosaic in place using strips of wood that have been clamped together. Use a set square to check that they are at right angles to each other.

→ *Soak the powdered terracotta while you are clamping the pieces of wood in place. It has to be very moist before being mixed with the cement or it will absorb the moisture of the mortar.*

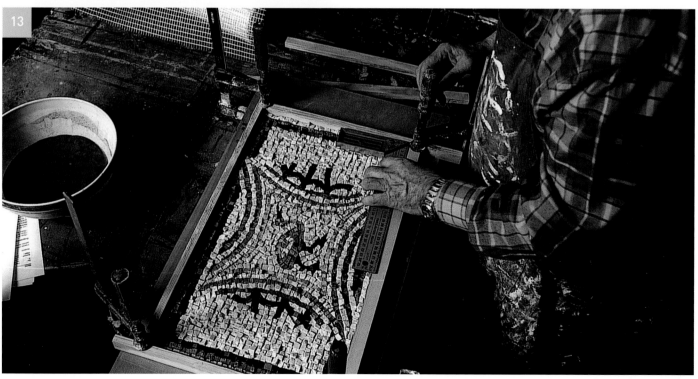

13

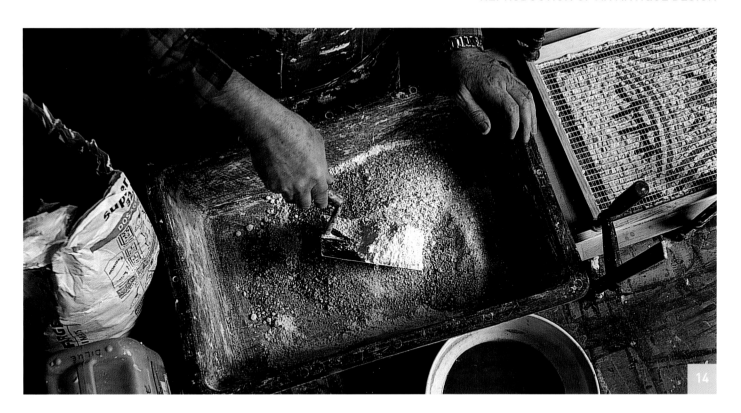

14

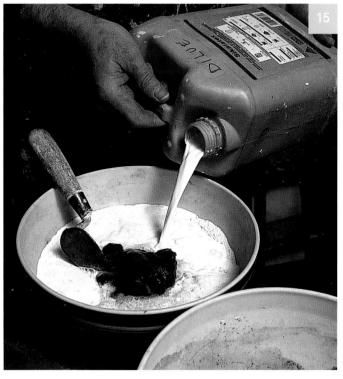

15

14. Prepare a mortar made up of equal parts of white cement and river sand (diameter 0.2mm). Add a diluted solution of Sikalatex (one part of Sikalatex to two parts of water). Sikalatex is a resin designed to improve the adherence and watertightness of mortar.

Mix the cement and sand together while dry before adding the diluted solution of Sikalatex. Mix with a trowel, gradually pouring in the Sikalatex solution. This should result in a firm paste that is not too liquid.

15. Make up another mortar using one part of powdered terracotta to two parts of white cement. This will strengthen the base. Add diluted Sikalatex. Unlike the first mixture, this mortar should be very liquid in consistency.

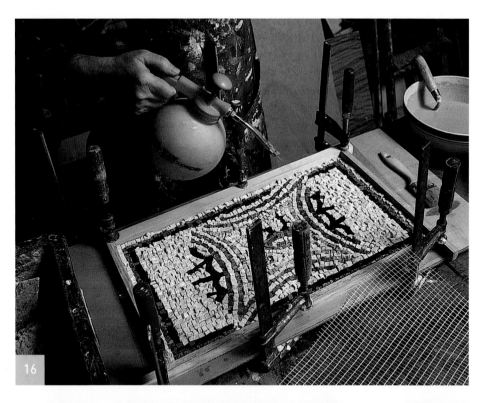

16. Once the two mixtures are ready, spray the tiles with water to moisten them. This will prevent them from quickly absorbing the moisture of the mortars.

17. Pour the more liquid of the two mortars (the mixture containing the terracotta) on to the mosaic.

→ *Caution: Do not delay as the mixture will harden very quickly.*

18. Use a paint brush to spread the mortar so that it slips into the gaps between the tiles. Strike the bench with your fist to encourage it to sink down.

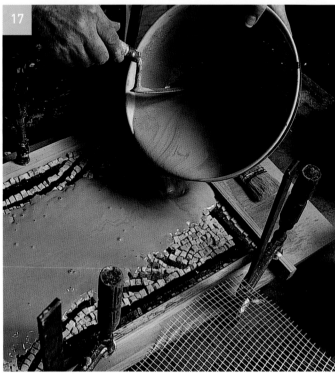

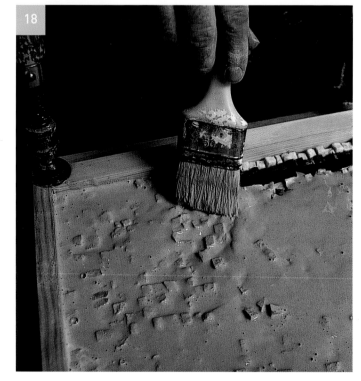

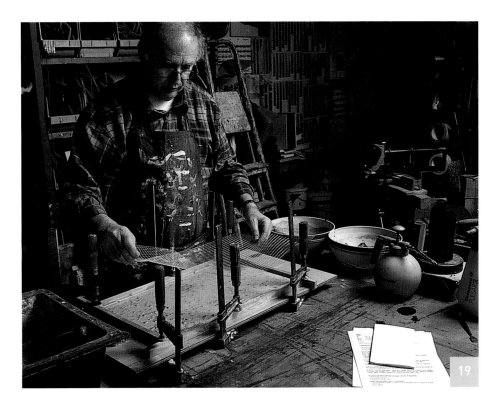

19. Place the glass-wool mesh on the mosaic. This is used to reinforce the cement and support the mosaic.

→ *If you are planning to install your mosaic in a floor, use metal netting to reinforce the cement.*

20. Use a trowel to spread the thicker mortar (cement and sand) smoothly over the entire surface. Use a level to check that the surface is flat, adding or removing cement as required.

→ *Sometimes the more liquid mortar overflows when the thicker mixture is added. Wipe off any spills with a piece of kitchen towel.*

→ *Once the mortars have been applied, carefully clean the trowels, bowls and brushes.*

Leave the mosaic to dry for two or three weeks. If it is more than 1 square metre (10½ square feet) in size, it will take longer to dry. During the first four days of the drying period, spray water on to the mortar once a day to strengthen it.

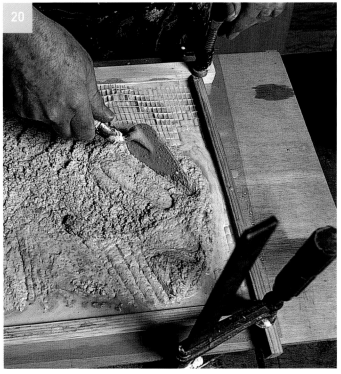

21. After two or three weeks remove the strips of wood and clean them immediately so that they can be re-used with another mosaic.

22. Turn over your piece of work. The hidden face of the 'reverse mosaic' will at last be revealed.

23. Put the mosaic, still covered with the glassine paper, into a large container and add hot or even boiling water.

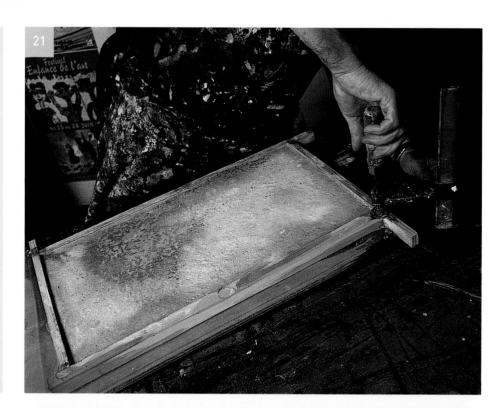

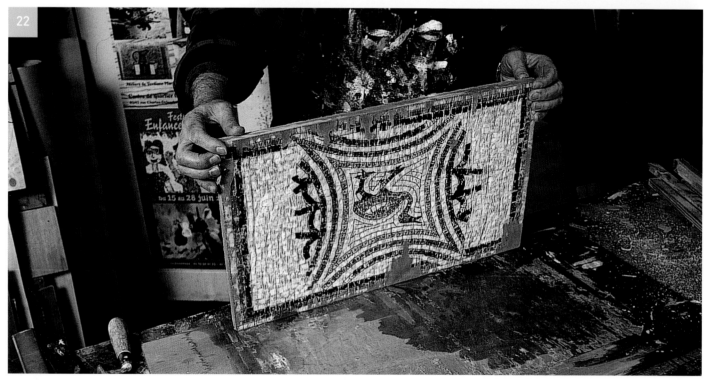

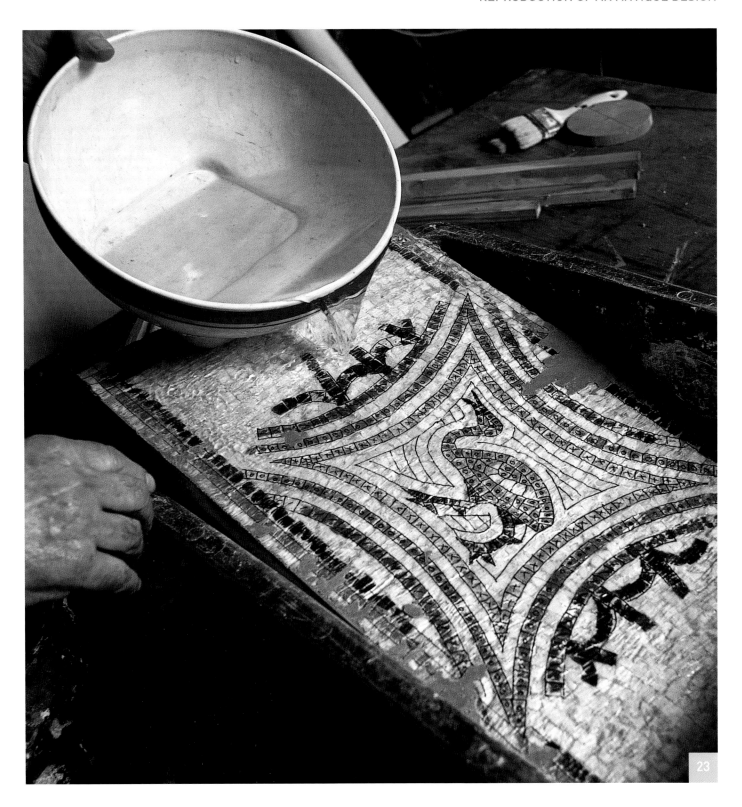

23

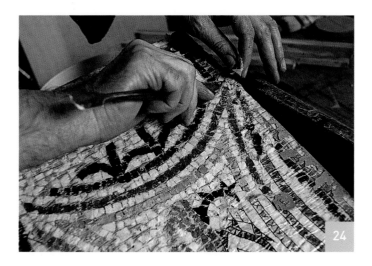

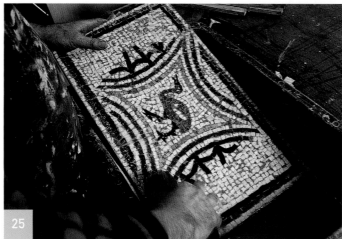

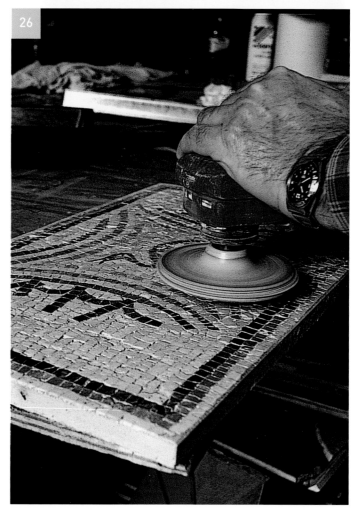

24 and 25. Remove the glassine paper by hand or with the end of a 'cat's tongue' trowel. Scrape off the excess mortar carefully, using a bradawl if necessary. Work over the mosaic with a plastic scrubbing brush, adding hot water to get it absolutely clean.

➔ *Never use a metal brush or you might scratch the tiles.*

26. To give the mosaic an antique look, sand it down several weeks after finishing it. Start with 50–60 grit sandpaper and finish by polishing it with 220 grit.

➔ *You can also give your mosaic to a marble mason, who will polish it for you.*

➔ *Another option is to make the tiles look old by shaking them for as long as possible in a metal box after they have been cut up. The ideal solution is artificial ageing in a makeshift mill or a washing machine. This way you can get rid of the neat cut edges of the tiles and make them look worn, as if the mosaic had been made centuries ago.*

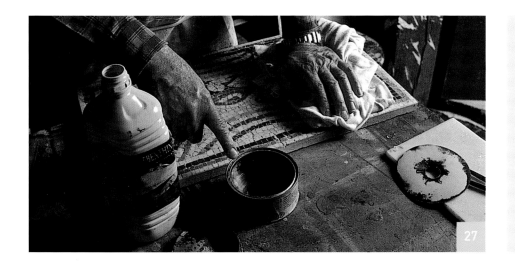

27 and 28. Finish the surface of the table with colourless beeswax which has been diluted with turpentine. This will brighten up the colours of the mosaic and prevent it getting marked by grease or wine stains.

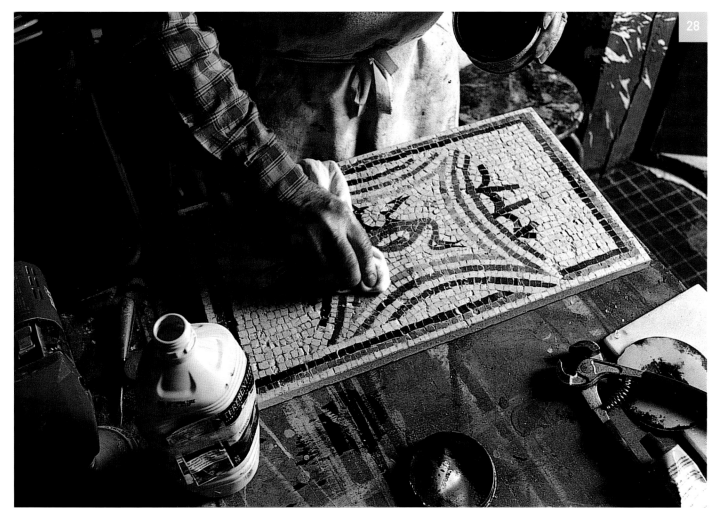

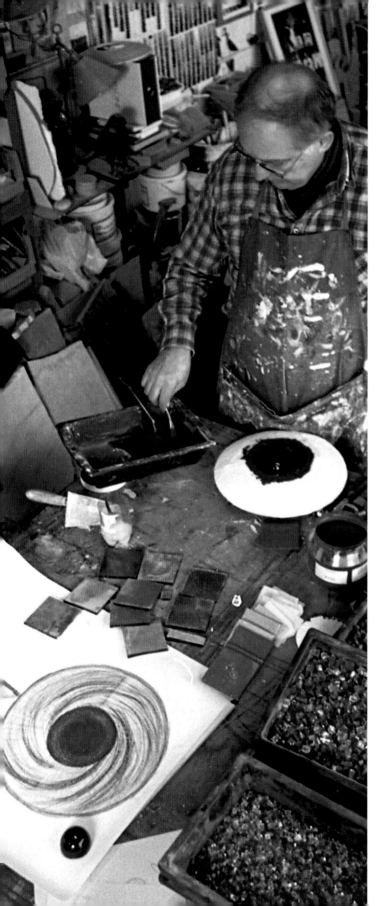

PROJECTS

TO DEMONSTRATE THE TECHNIQUES YOU HAVE
LEARNED, VERDIANO MARZI HAS DESIGNED A
SERIES OF OBJECTS THAT RANGE ACROSS THE
CREATIVE SPECTRUM, FROM ANTIQUE COPIES TO
CONTEMPORARY ART, MUTED OR FLAMBOYANT
COLOURS, CLASSICAL OR FUTURISTIC DESIGNS,
MOSAIC CAN BE ADAPTED TO SUIT YOUR NEEDS. IT
IS NOW UP TO YOU TO CREATE YOUR OWN
COMPOSITION WITH THE HELP OF THE FOLLOWING
SUGGESTIONS.

Ibis motif table

It was the elegance of the ibis, personified by the god Thoth in Ancient Egypt, that inspired Verdiano Marzi to reproduce this motif on a coffee table. From the original fragment (an ibis bordered with black on a cream-coloured background) he has created a multicoloured mosaic featuring yellow ochre, brown and terracotta. In this piece he has combined several different types of marble: Alicante Red, brown marble from Aquitaine, Spanish Marron Emperador, Crema Marfil and black marble from Morocco, Belgium and Spain (Marquina).

You can either follow his lead, adopting this colour scheme, or keep to the original, or why not bring a two-tone 'designer' look to the antique polychrome? You can cover the entire tabletop with tiles, as in this example, or create a faux antique piece by allowing the mortar to appear in places. In this case grit may be added for a rougher consistency that will make the table look older. Alternatively, you can use coarse-grained terracotta to accentuate the effect of the material or slaked lime with marble powder.

TECHNIQUES USED

- Tile cutting, pages 48–51
- The indirect method on paper, pages 70–85

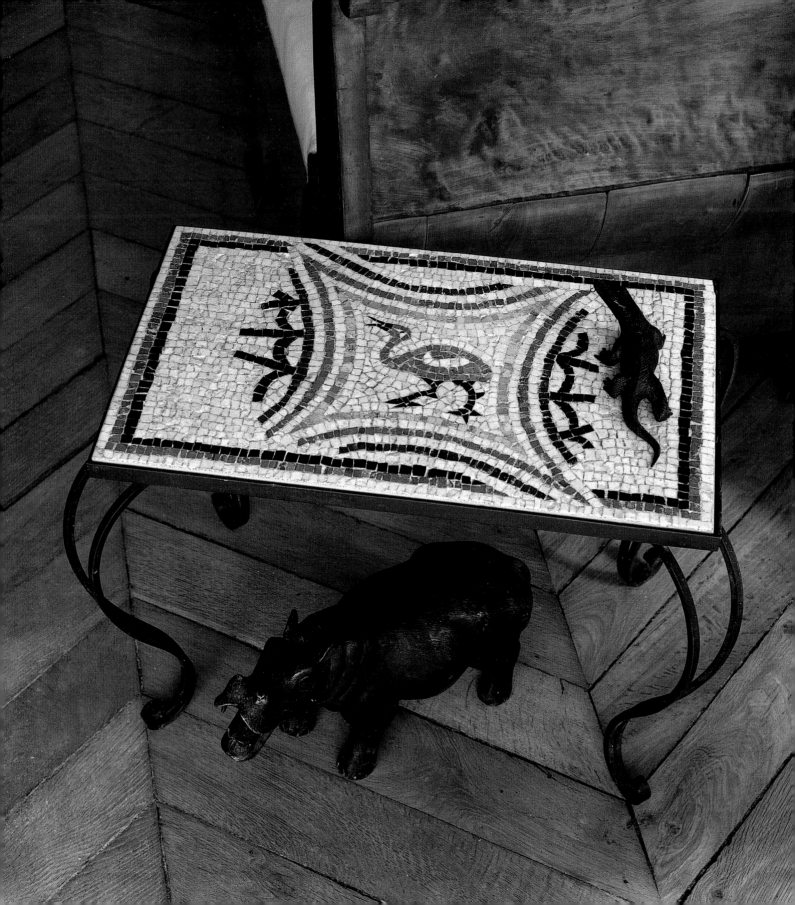

A modern-day frieze

Verdiano Marzi has designed a very contemporary frieze for a slate-tiled bathroom, which also features a water channel decorated with pebbles. Wishing to break up the monochrome look of this decor with its smooth, velvety reflections, Marzi has opted for white marble combined with glass in bright shades of red, orange and green. This burst of colour is combined with an undulating rhythm that acts as a perfect counterpoint to the geometrical forms of this designer bathroom. Here the brilliance of the rippling freeze is like an explosion against the greys of the slate and pebbles. This design, which is based on a repeating pattern, is created using the mesh method with fairly large tiles. It can easily be made at home as it does not take up much room.

TECHNIQUES USED

- Preparation, pages 40–51
- The mesh method, pages 62–69

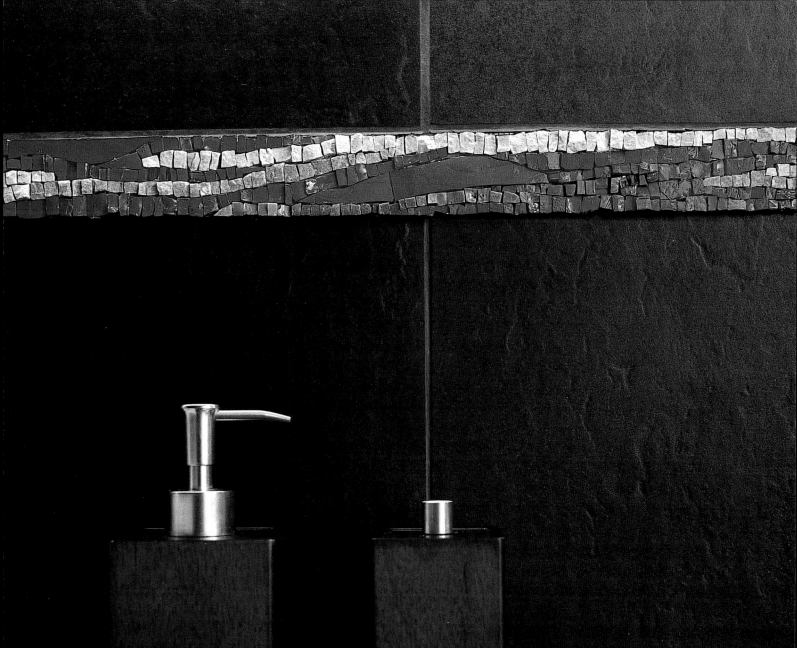

1 > 2 > 3 > 4

Verdiano Marzi clamps together strips of wood to make a frame, 85cm (33½in) in length, which is the same size as the motif. This will keep the frieze in place while he lays the tiles.

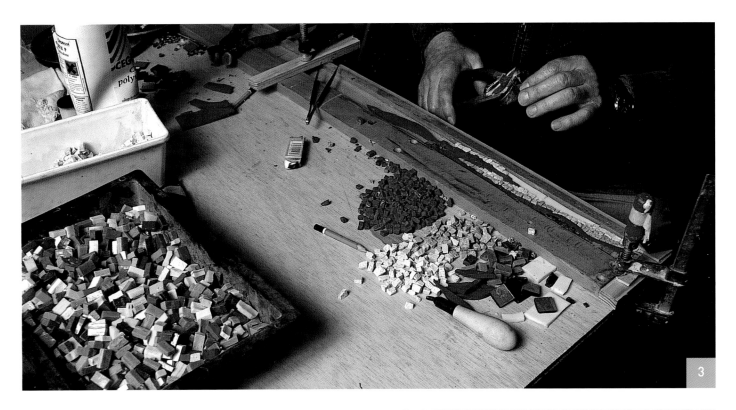

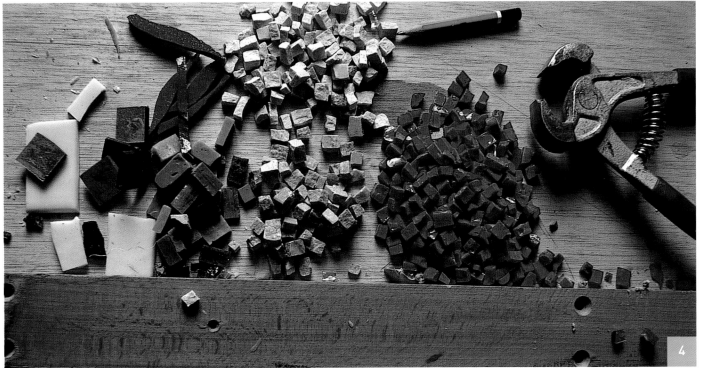

A wall lamp

Verdiano Marzi has used a dish made of glued strips of bamboo to make a wall lamp with a concealed light bulb. It is designed so that the light can escape at the sides in a glow of white while condensing into a burning sun in the centre. Verdiano happened to buy this crimson-coloured disc one day from Albertini's factory without any clear idea of what he was going to do with it. At home one morning, the sight of the dish sitting on a table gelled in his mind with a picture of the red star. Verdiano grabbed the dish and carried it off to his studio, where he turned it over, cut out the middle and decorated it with a mosaic featuring this central translucent element. Now showcasing this curious-looking, mysterious eye, the dish has been transformed into a decorative lamp giving off a muted glow with the help of glass tiles in gold leaf.

TECHNIQUES USED

- Preparation, pages 40–51
- The direct method, pages 52–61

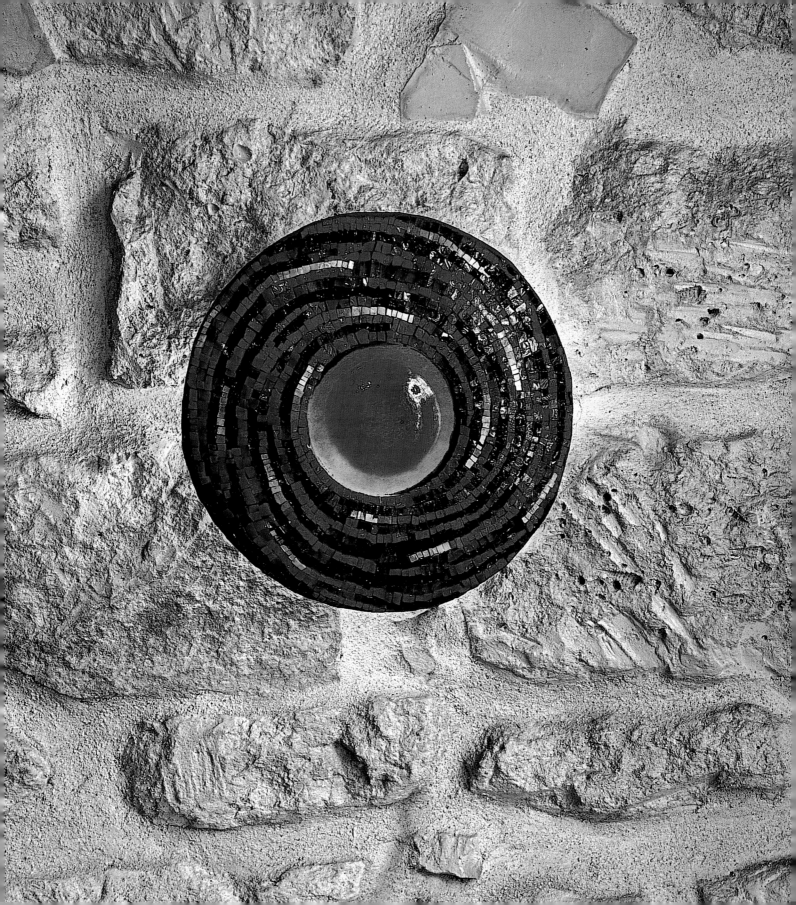

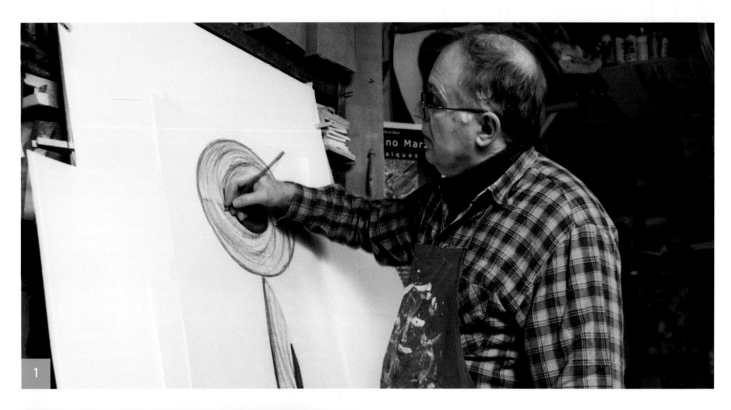

1 > 2

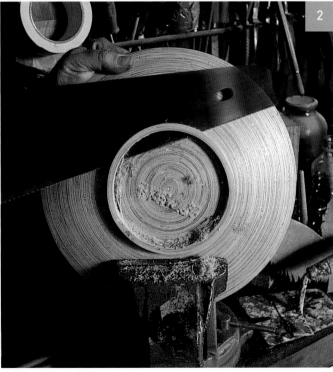

Trace the design of the mosaic, adapting it to the shape of your base (here a dish made of glued strips of bamboo). Draw the front view as well as a cross-section to get a proper idea of the volume of the object. Use coloured pencils to add strokes that spiral out from the centre. This will create a faint pattern of lines suggesting how the tiles should be arranged.

Select and assemble the materials you require – in particular the central eye in coloured glass, which acts as the centrepiece for the play of light.

Use a wood saw to cut off the bottom of the dish, which will then form the base for the mosaic.

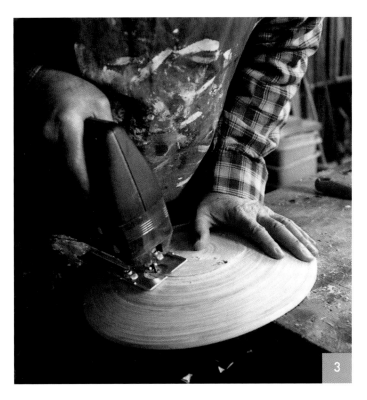

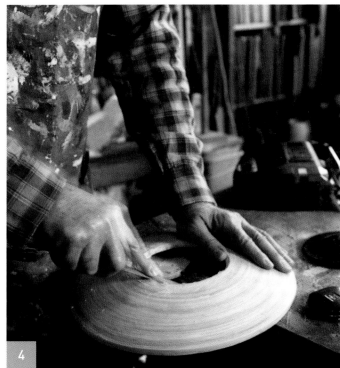

3 > 4 > 5

Cut out the middle of the dish. The measurement used here is the size of the central eye, less 2–3mm (approx. ⅒in) otherwise the disc will fall through. To do this, make several holes using a drill and cut out with a jigsaw.

Bevel off the edges with a rasp so that the eye will easily slip into the opening.

Attach a piece of galvanised wire to the back to fix the lamp to the wall, as well as three pegs to serve as spacers. This will allow the light to escape on all sides (preferably with the use of a cold bulb, to prevent the mosaic from getting too hot).

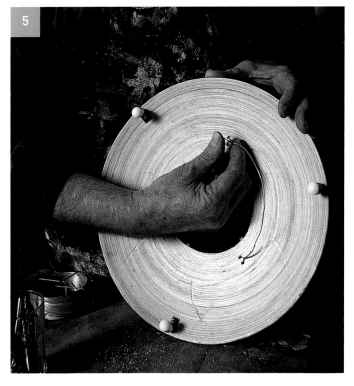

6 > 7 > 8 > 9 > 10

Apply a coat of Isolastic to the back to protect the wood from the moisture in the mortars.

Strengthen the base by applying an initial coat of mortar to which you add pieces of glass wool. Prepare the coloured mortar in which the tiles will be set.

When making the mosaic, start in the middle by first fitting the coloured eye in place.

Lay the tiles, working outwards as you go.

Make sure the gold in the tiles faces upwards or they will be dulled by the mortar.

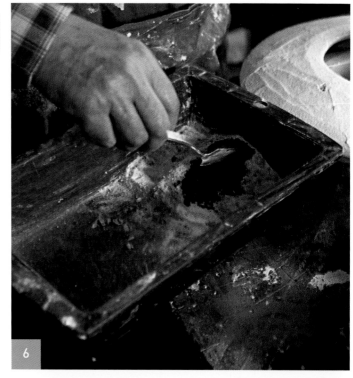

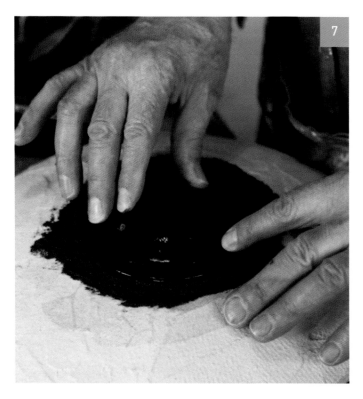

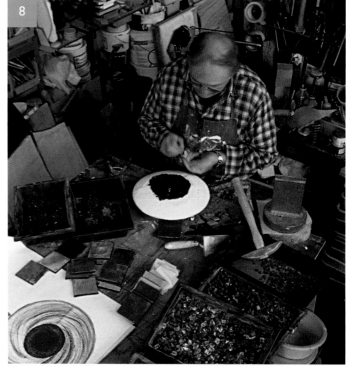

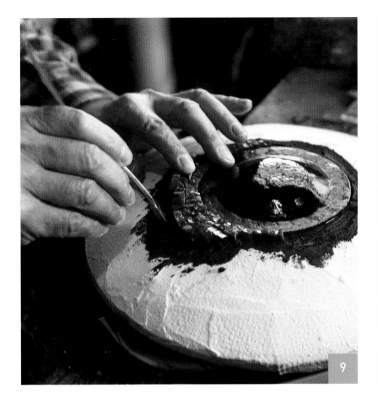

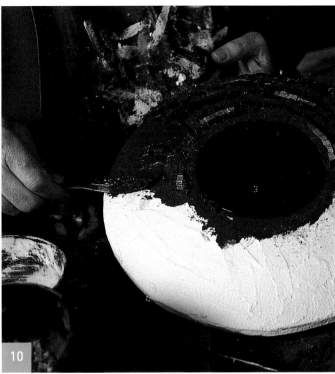

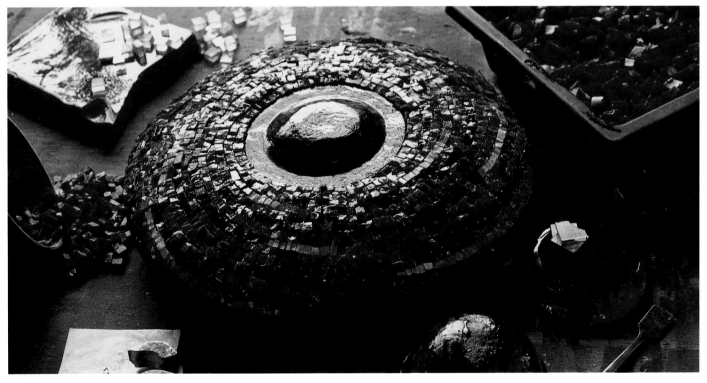

A new lease of life for a mirror

For Verdiano Marzi, breaking a mirror does not bring bad luck, but rather represents a new start. Instead of being thrown away, the broken glass is mounted on a plywood base and decorated with mosaic.

The crack is the inspiration behind a composition that combines different shades of mirror glass, highlighted with touches of blue and green.

The design depends on how the mirror has broken. The break is disguised with mosaic tiles and can be turned into a tree, flower or anything you like. The broken fragments of the mirror are cut to size and made into tiles, and then they are combined with vitreous glass in gold and silver, as well as blue and green tesserae that look like semi-precious stones. Around the edge of the mirror Verdiano creates a monochrome geometric frieze that is based on a design from Ancient Rome. This project can just as easily be adapted to a mirror that is not even broken.

TECHNIQUES USED

• Preparation, pages 40–51

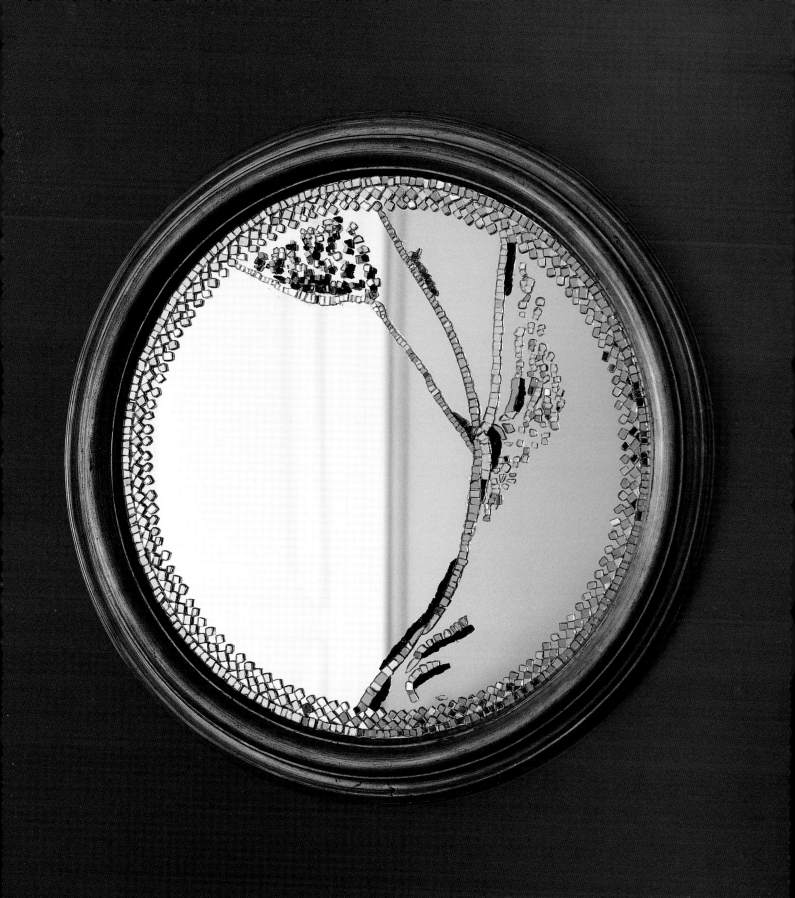

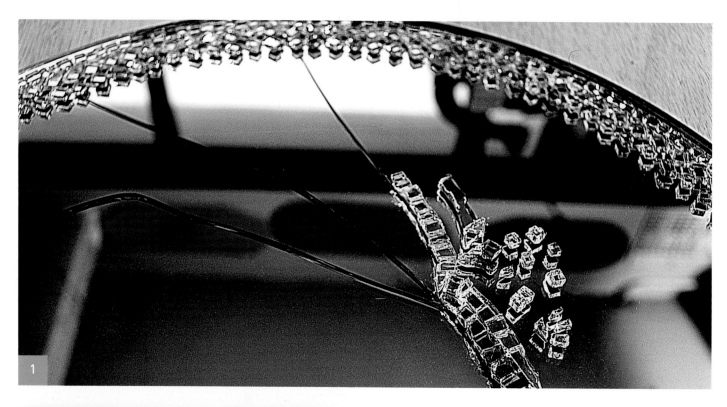

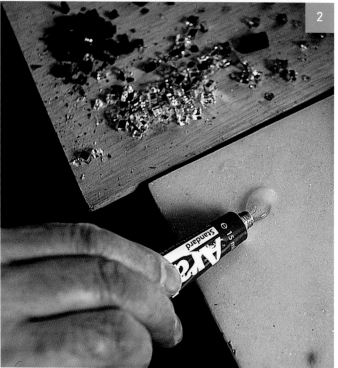

1 > 2 > 3

The technique used here is simple: all you have to do is glue fragments of the mirror and vitreous tiles to the surface of the mirror using Araldite.

Cut the fragments of the mirror to size using the cutters. In this example Verdiano Marzi has used fragments from two mirrors which are different colours.

Use a pair of fine tweezers to move the tiles into place.

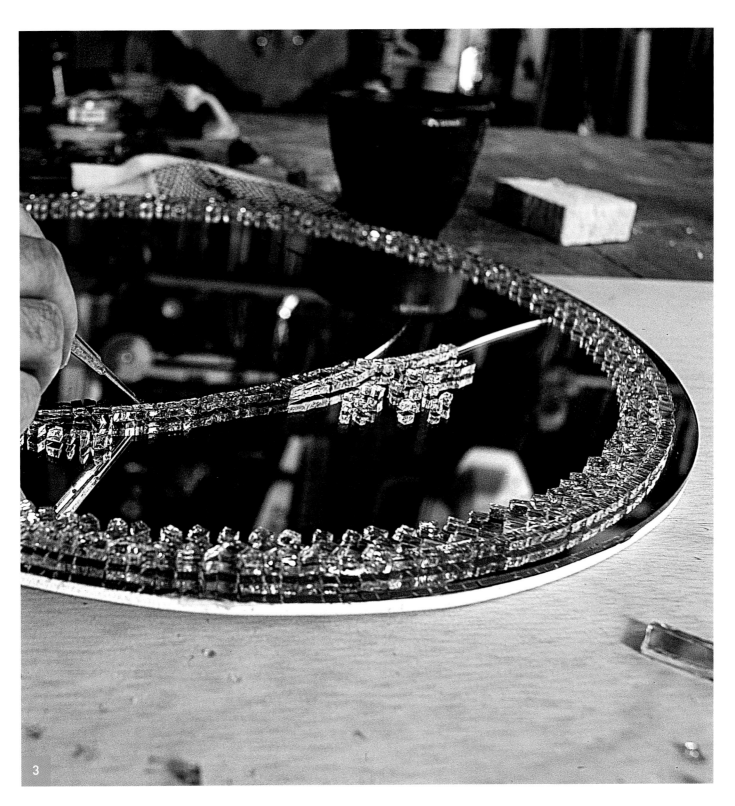

3

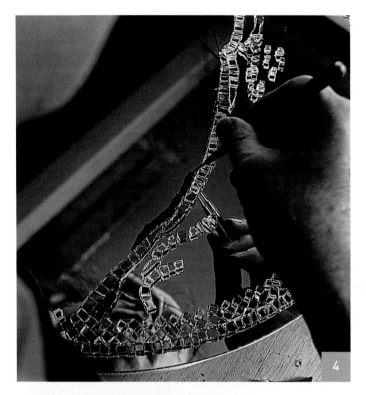

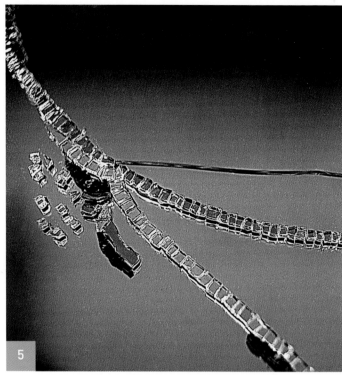

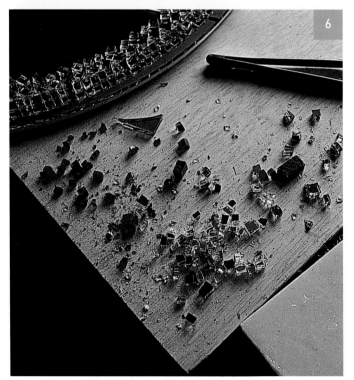

4 > 5 > 6

Finish by wiping off all traces of adhesive from the glass using a rag. Lay the mirror flat and allow it to dry for 24 hours (if you hang it up, the tiles might slip before the glue is completely dry).

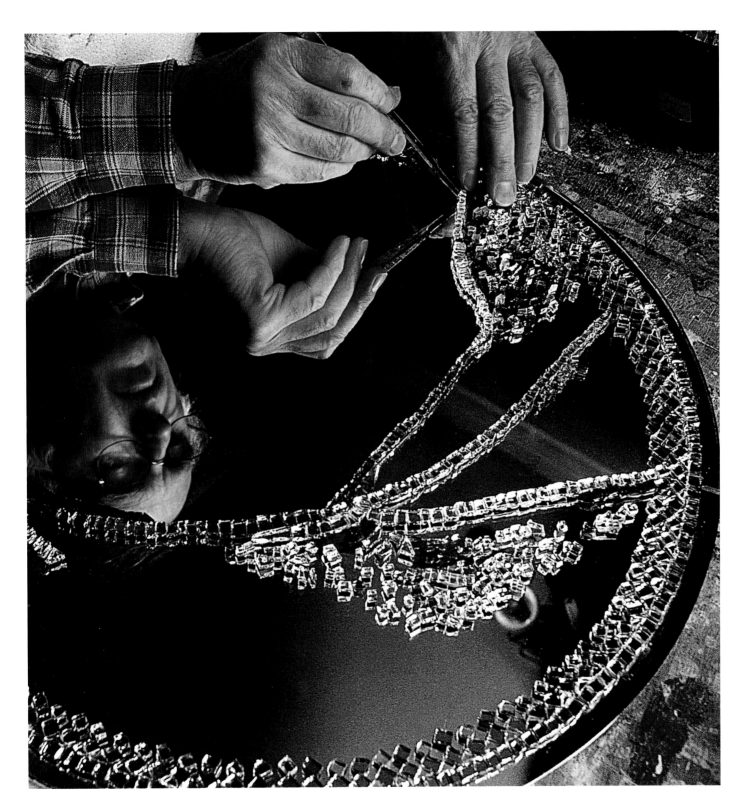

Bird sculpture

In the pre-Columbian era, the American Indians made mosaics out of the same feathers that were used in their ceremonial costumes. Verdiano Marzi, however, has made the feathers of his mythical bird out of mosaic. He has managed to conjure up the satin sheen of a feather with the help of vitreous tiles. To create the curved lines of the bird's folded wings he has used fine, translucent slivers of glass collected from Albertini's garden. The entire sculpture, from its outline to the choice of materials, gives the bird a light and airy feel despite having its feet set firmly on the ground. With its beak lifted to the sky and water swirling around its feet, it looks as if it is about to fly away at any moment.

TECHNIQUES USED

- Preparation, pages 40–51
- The direct method, pages 52–61

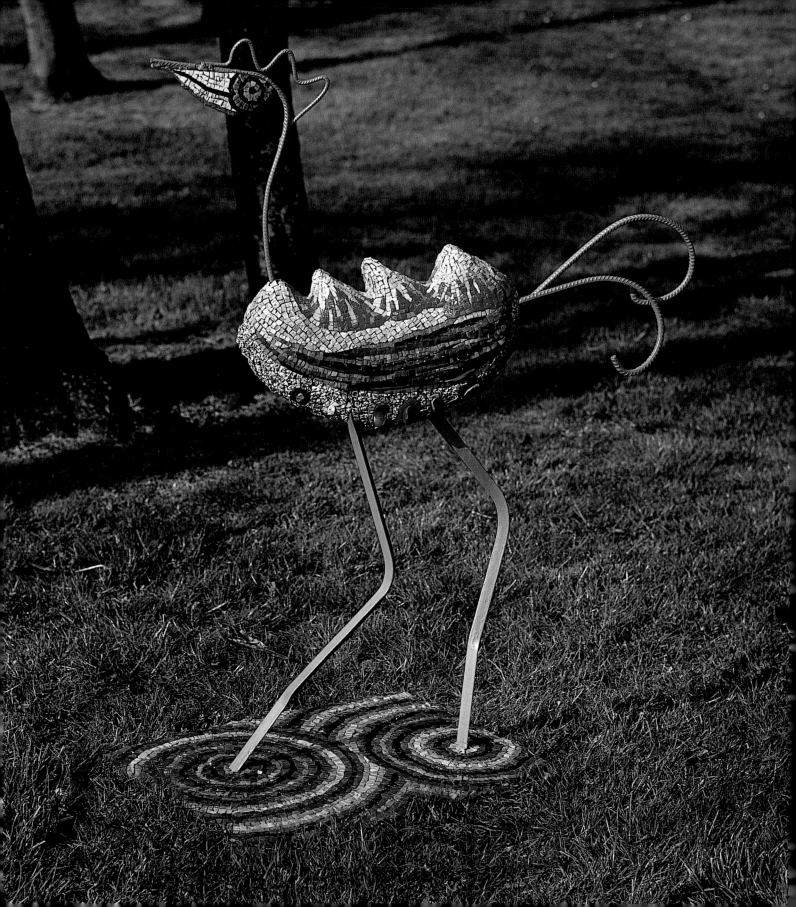

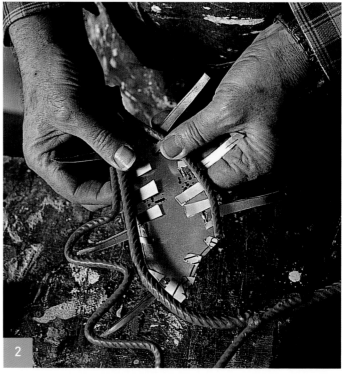

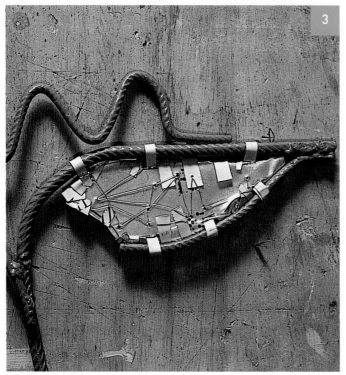

1 > 2 > 3

To make a base for the mosaic on the bird's head, cut out a piece of aluminium the same size as the beak, leaving tabs around it.

Use the cutters or a chisel and hammer to make little slits in the metal sheet to act as 'buttonholes' for the fixing tabs.

Fix the metal sheet in place by winding the tabs around the beak and inserting them in the buttonholes. Sew the ends down with brass wire to prevent them from coming undone. When you have finished, pierce tiny holes in the metal to make it rougher and provide a key for the mortar.

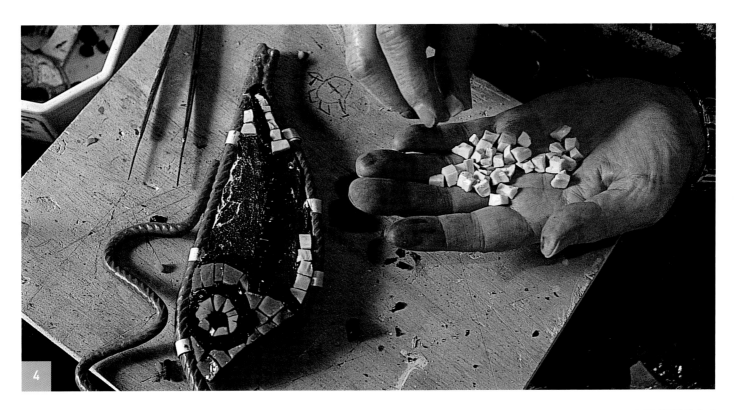

4 > 5

Use the point of a trowel to draw the eye and a dividing line in the middle of the head in the fresh mortar. Start by laying the tiles for the eye and the middle part. The tiles become smaller as you move along the beak. Cut a tile to size to fit at the end of the beak. However, do not use any tiles under the eye: the mortar here remains bare.

→ *When working on small areas, there is no need to start in the middle and work outwards.*

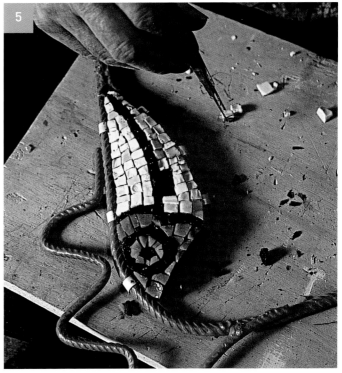

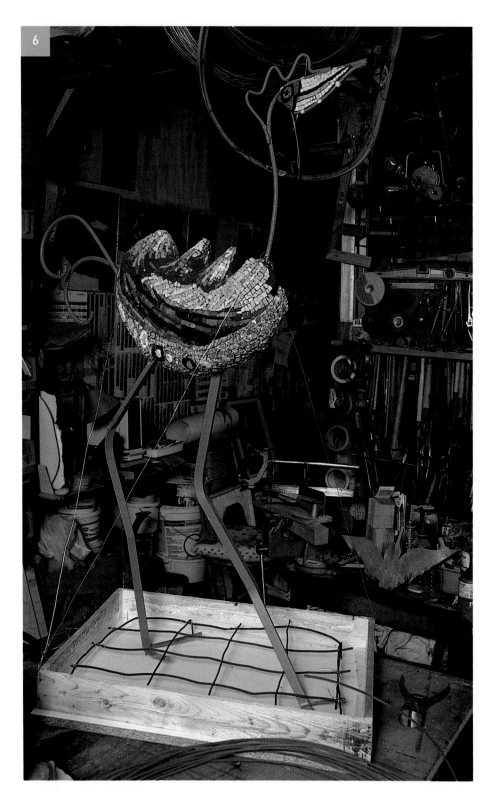

6 >

Place the sculpture on a plinth made out of old pallets, securing it with metal wire joined to the pedestal. Cover the joints with Sellotape to make them waterproof. The pedestal must be wide enough to prevent the sculpture from toppling over.

Make a metal bracing structure to reinforce the mortar, using 5mm (¼in) diameter annealed wire. Use this wire to fashion handles on the sides of the plinth as well, so that the sculpture can be easily moved once you have finished it.

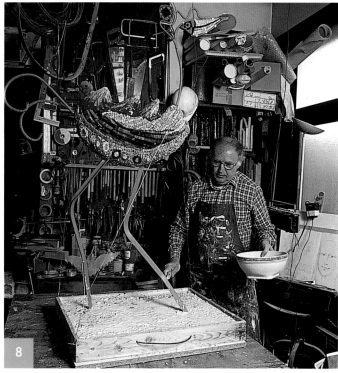

7 > 8 > 9

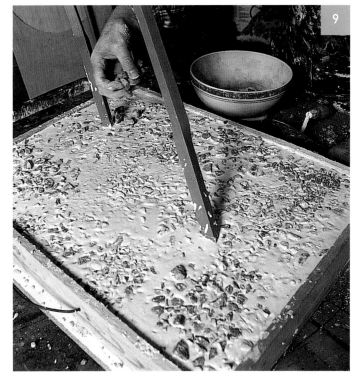

Prepare a mortar made up of equal parts of gravel, sand and cement. Mix these materials together while dry and then add Sikalatex to produce a thick paste.

Pour the mixture into the pedestal until it is halfway up and position the metal reinforcement.

Fill the pedestal to the brim, spreading out the mortar. Allow it to dry for four days.

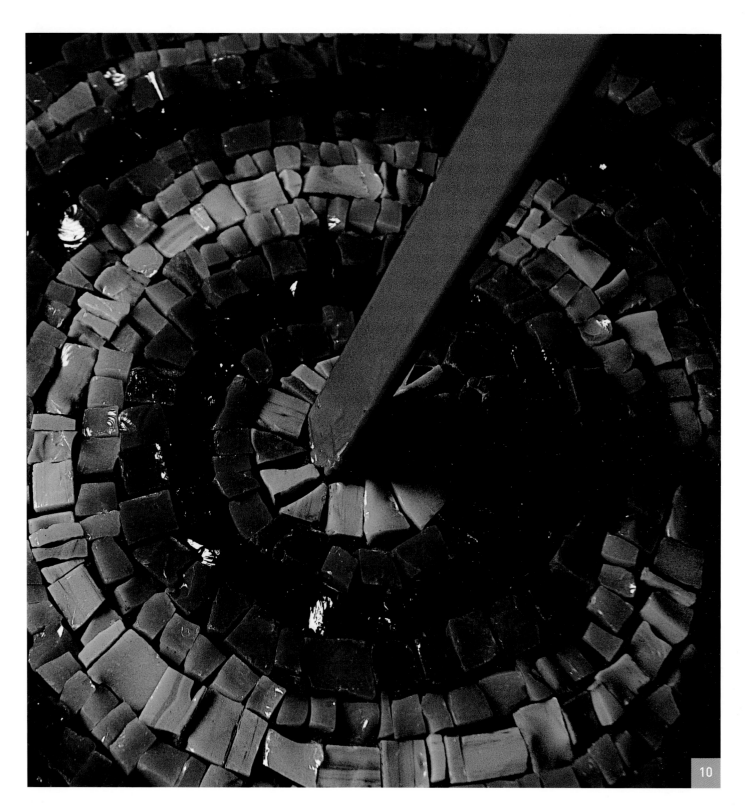

10

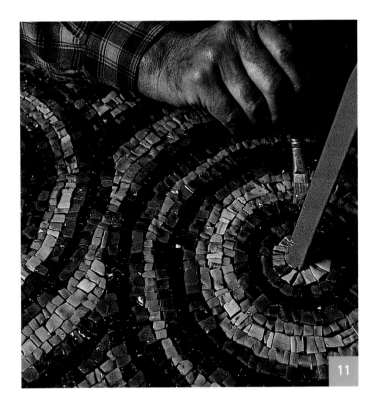

11

10 > 11 > 12

Make up the mortar to be used as the setting bed and start laying tiles on the plinth. Cut large blue tiles of different shades and arrange them in concentric circles around each foot.

To finish the sculpture, scrape off any cement on the legs and paint a coat of rust preventer on the metal parts of the bird (feet, tail, neck and head).

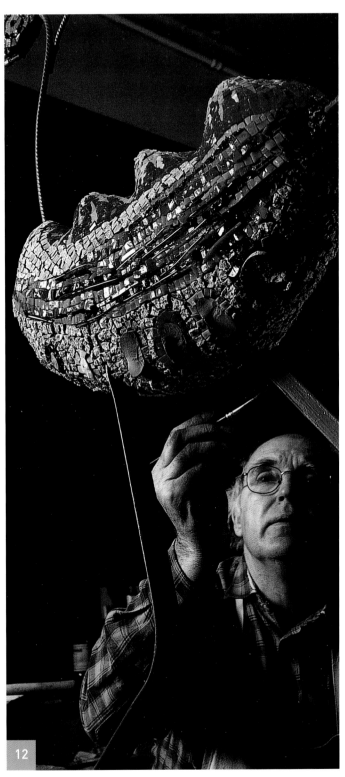

12

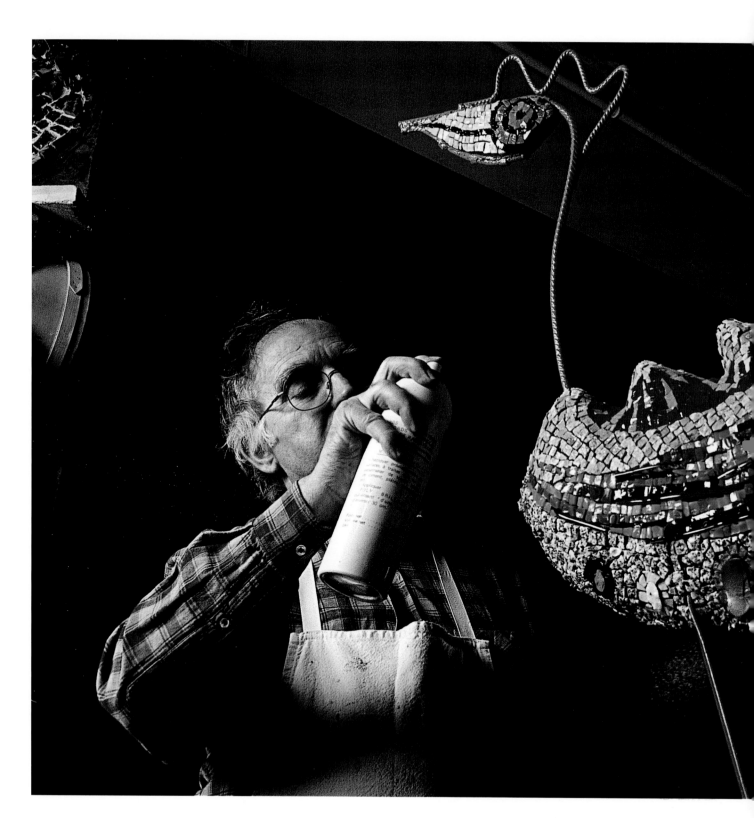

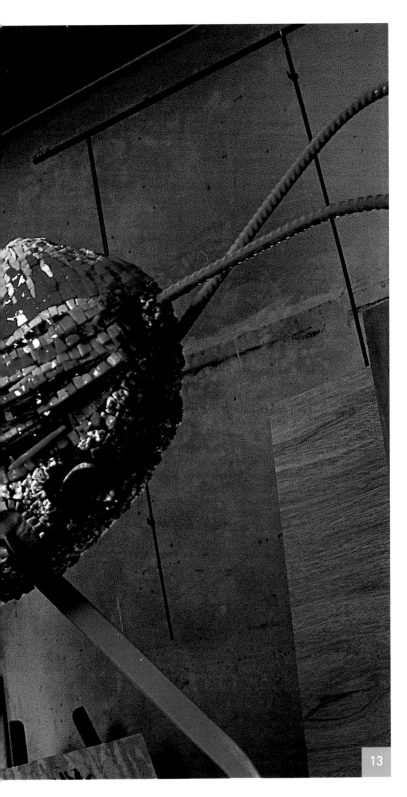

13>

Depending on where the sculpture is going to stand, either apply a spray coating that will make the mortar more waterproof or use another product that will bring out the shine of the materials.

→ *If the sculpture is being installed in the garden, bury two-thirds of the plinth in the ground to hide it and make the bird more stable.*

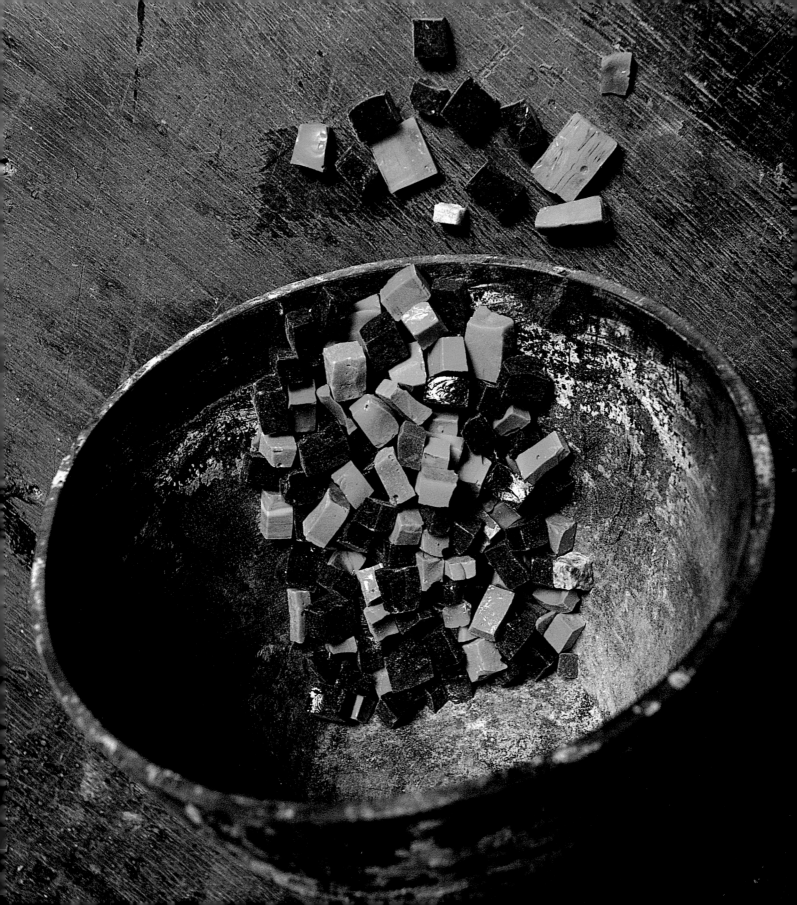

GLOSSARY OF MOSAIC MAKING

Cartoon: the drawing made by the *pictor imaginarius* as the design for the mosaic.

Commesso di pietre dure: 'stone mosaic pictures', a term used for mosaics where hard stones are fitted together without gaps to resemble a painting.

Cosmatesque technique: a form of *opus sectile* (see below) that was invented at the Cosmati studios.

Hardie: a blade inserted in a base, which forms a sort of guillotine with the hammer when it strikes the material to be cut.

Interstice: space between two tiles.

Marble: crystalline rock.

Martelina: Italian for a mosaic hammer – a metal hammer used by a mosaic artist, which has sharp edges at both ends.

Mortar: a mixture of cements or binders. A distinction is made between base mortar, which is used to cover and strengthen the base, and the setting bed, a mortar that is not as thick and is generally coloured, and is used to fix the tiles in place. With paving, an extra layer of mortar is sometimes added to reinforce the floor or retain the moisture.

Mosaico in piccolo or micromosaic: small portable works made using tiny tiles – one square centimetre (approx. ¼ square inch) may contain up to 220 tesserae!

Opus: Latin for 'work'. This term is used to distinguish the different techniques of mosaic work seen over the years.

Opus musivum: mosaic decorating walls or the vaults of caves or man-made grottoes. It was dedicated to the Muses (musaea) and used to adorn Roman gardens. The word *mosaic* is derived from this decorative genre.

Opus reticulatum: mosaic in which the tesserae are laid out in oblique lines in relation to the frame.

Opus sectile: mosaic featuring geometrical paving made up of large tiles.

Opus signinum: mosaic featuring Hellenistic geometric patterns.

Opus tessellatum: mosaic made from tesserae measuring around 8mm (⅓in) at the side. This type of mosaic appeared in the Hellenistic era and all but took over from the pebble technique after the second century.

Opus vermiculatum: Hellenistic mosaic used to outline complicated motifs, combining small tiles measuring less than 4mm (⅛in) . One square centimetre (approx. ¼ square inch) may contain up to 68 tesserae.

Pebble: a stone that has been worn away and polished by the sea or a river.

Setting bed: mortar, often coloured, used to fix the tiles in place.

Sinopia: this term is sometimes used to refer to the design drawn by the *pictor imaginarius* on the setting bed to guide the artist when laying the tesserae.

Smalti or enamel: slabs obtained by melting coloured glass and lead.

Tessera or abaculus or tessella: a fragment of vitreous glass, marble or other material used for mosaic work. Art historians and archaeologists tend to speak of the abaculus. Tesserae are generally cubic or parallelepiped in shape, although they can also be cut into other geometrical shapes as needed.

Vitreous glass or enamel: slabs obtained by melting sand, calcium oxide, sodium oxide or potassium oxide with colouring agents.

CONTENTS

ACKNOWLEDGEMENTS

Verdiano Marzi would like to thank his wife Béatrice for her patience and constant support as well as Gino Severini, Renato Signorini, Riccardo Licata and Isotta Fiorentini Roncuzzi.

Fabienne Gambrelle would like to thank André Gambrelle. Her warmest thanks also go to Pierre Verdrager and Jean-Michel Vinciguerra, who made her meeting with Verdiano Marzi possible.

The authors would also like to thank Gérard Albertini.

The editor thanks Bertrand Meurice, the architect who designed the bathroom shown on page 91.

All photographs are the work of Florent de La Tullaye except for the following:
page 8, Bridgeman Giraudon; page 9, Roger Viollet;
pages 10–11 and pages 12–13, G. Dagli Orti, Paris; page 14, Bridgeman Giraudon;
page 15, Jean-Claude Guilloux.

First published in Great Britain 2010 by Search Press Limited,
Wellwood, North Farm Road, Tunbridge Wells, Kent TN2 3DR

Published originally under the title: 'Secrets d'ateliers – Les Mosaïques'

Copyright © 2005 by Éditions Solar, Paris

English translation copyright © 2010 Search Press Limited

English translation by Cicero Translations

English edition edited and typeset by GreenGate Publishing Services

ISBN: 978-1-84448-506-2

Graphic design and production (French edition): Guylaine Moi

Photoengraving: Articrom

Printed in Malaysia